Modern Art

Henri Matisse
Cateau-Cambrésis (Nord) 1869-Nice 1951
The Rumanian Blouse, 1940
Oils on canvas 36″ × 28″
Musée National d'Art Moderne, Paris

Modern Art

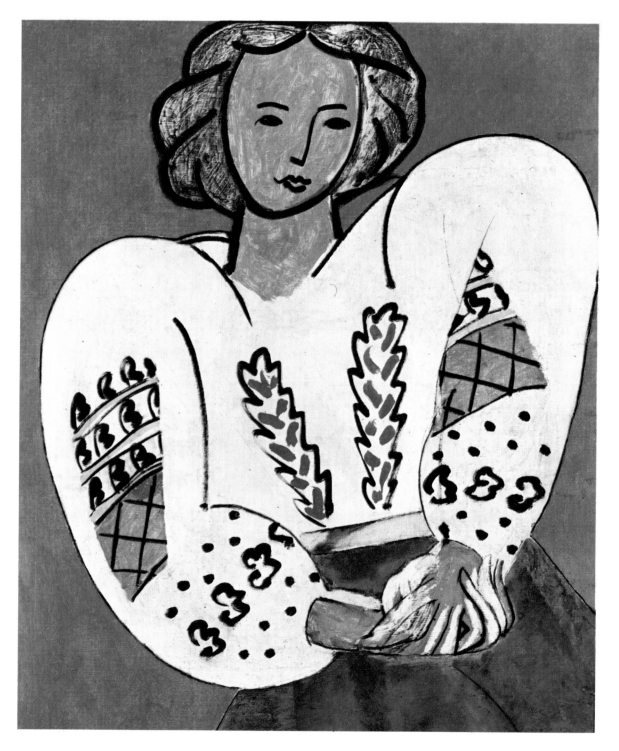

PEEBLES ART LIBRARY, Sandy Lesberg, Editor

First published 1974
by
Peebles Press International
U.S.: 140 Riverside Drive, New York, N.Y. 10024
U.K.: 12 Thayer Street, London, W1M 5LD

ISBN 0-85690-026-5

Illustrations provided by:
Giraudon, Paris: pages 11, 16, 17, 18, 19, 20, 21, 22,
23 (upper right and lower), 24, 28 (upper), 29, 34, 35,
37, 38, 39, 41, 45, 46.
André Held, Lausanne: pages 3, 8, 10, 12, 13, 14, 15, 16 (upper),
25, 26, 27, 28 (lower), 30, 32, 33, 36, 40, 42, 44, 47, 48.
Garanger, Paris: pages 7, 9, 23 (upper left).
Bayeler, Basle: page 31.

Distributed by
Walden Books, Resale Division in the
U.S. and Canada.
WHS Distributors in the U.K., Ireland,
Australia, New Zealand and South Africa.

Printed and Bound in Great Britain

Introduction

It is often said that the great periods in art are those which attain unity of expression; and that this unity derives from a harmony between the various art forms: the musician, the poet, the architect, the painter and the playwright existing within one and the same movement of thought, and works of art in each category reflecting works in other fields. Examples thus relate collectively and individually to neighbouring disciplines, as they do to the people for whom they are intended.

Such an interrelationship is often held to be lacking in the painting of our own time—let us say, from the beginning of the 20th century; it tends to look as though the ties that unite painting with other means of artistic communication have become insignificant. The artist is reproached today with seeking originality at any price, of inventing for himself a vocabulary of which he alone knows the true meaning, and of evading all imitation, whether of nature or art: he now wishes to paint neither the face of the world nor the faces of people, and desires to be close neither to the old masters nor to artists who are his contemporaries.

We may be disturbed by the short-sightedness of such criticisms of present-day art. But we should also be grateful: nothing is more dangerous than general acquiescence, the consensus of praise which accompanies the careers of certain artists. And those who see in the art of the last fifty years nothing but disorder, wilful eclecticism, and a refusal to develop from traditional ideas, would be astonished if shown what discordances have been expressed by some of the painters whom they regard as being in line with unity of expression. . . .

Here, as elsewhere, in art criticism as in literary criticism, generations follow and resemble each other: within each one there are always some for whom truth and splendour are the prerogative of the dead; particularly the national dead, interred with the highest ceremonial. These individuals extol the struggle of the dead against destiny, heap anathema on those who failed to recognise the genius of their contemporaries; and, satisfied with thus having "defended" heroic art, the art of mixing colours, they turn back to the living. And to the living they turn a different face: contemporary painting and the plastic arts in general, they say, have not conquered minds and hearts; they have no place in the city except by gate-crashing, against the citizen's consent. . . .

Witness for the past, judge for the present: there is the paradox. Artistic judgement cannot claim to spring from eternal justice, inspired by immutable values. Criticism itself forms part of the history of art, and it furthers artistic creation by identifying new values. Besides, the best and most lucid art criticism (such as is practised by Georges Charensol) is essentially actual, modern; *it evolves within a moving present.*

At least, this is how the best of modern criticism manifests itself. It knows the museums, but does not wait for an art gallery to become a museum before making its pick, latching on to something just beginning, something which is going to exist for the future. The true critic is the true contemporary, who looks with hope and for whom everything is new. "As for criticism as such," wrote Baudelaire just over a hundred years ago, "I hope the philosophers will understand what I am trying to say: that criticism, if it is to be fair and justify its existence, must be partial, impassioned, political—that is to say, formed

from a point of view which is exclusive, but a point of view which also reveals the widest horizon."

And Zola: " When the masses do not understand, they laugh. A complete education is necessary before it is possible to accept genius."

Art criticism which gets genius accepted can become confusingly involved with the battle for art. But there is no such thing as Art per se—*contrary to a woolly conviction which is at the basis of many judgements. There is only actual, material art. And for every critic art will mean something different.*

It is only through the art of the present that we are able to understand the art of the past. That which is no more can be understood only in terms of that which is. The present is father to the past, and criticism to the history of art (Bernard Groethuysen).

Can anything be added to these laws of artistic understanding? When Georges Charensol quotes Guillaume Apollinaire, Blaise Cendrars, Mac Orlan, Max Jacob and several other important writers in his descriptions of Picasso, Léger, Van Dongen, Modigliani, Utrillo and Derain, he is naming that fraternity which allows the reader to enter the painters' world, not by a side-track, but by a parallel path. Things connected by time, common experiences, and the same struggle cannot be separated. Reality—which people accuse artists of having rejected (the accusation dates from the mid-19th century, but continues to be popular)—is experienced in a disjointed, piecemeal, and immediate fashion as much by poets and novelists as by painters.

Writers, however, have words which hardly change, even if they can be rearranged. The vocabulary of modern painting on the other hand is accessible only through a general effort of understanding. Today's painting is collectively and individually related, like that of all the great periods; related to problems and to agonies, to the experiences of ordinary living people. The latter must either learn to look *at writers at the same time as they look at painters, or else give up trying to know the truth about their times. Everything in art which spans the centuries possesses a significance, everything speaks of man, his passions, his dreams, his deaths, his renewals. Art is also a story, the most profoundly expressive there has ever been. What man dreams is his portrait, Hegel said. What man desires is his art. But it is not necessarily true that those who desire are contemporary with the art of their time. . . .*

Gilbert Sigaux

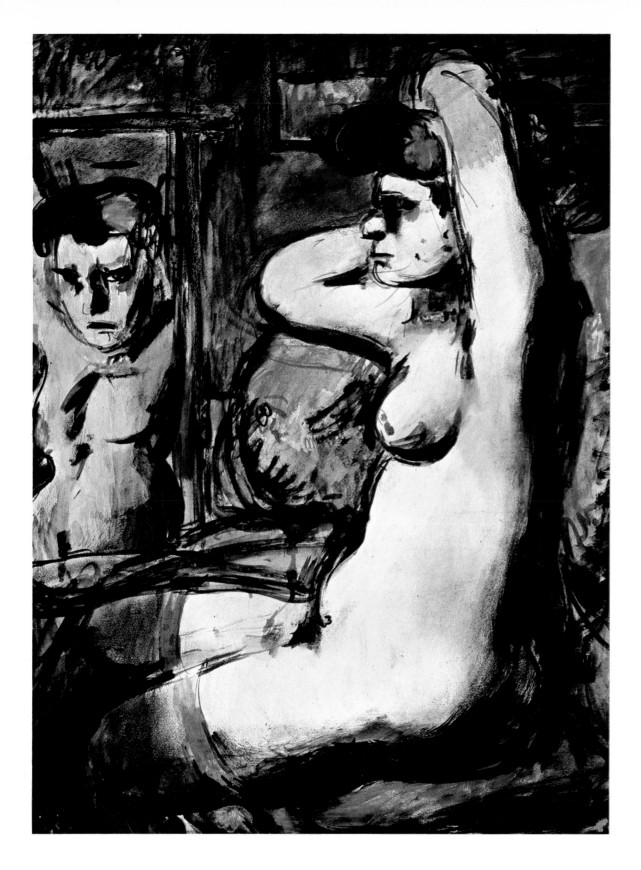

Georges Rouault
At the Mirror, 1906
Water-colour on hardboard 28″ × 21″
Musée National d'Art Moderne, Paris

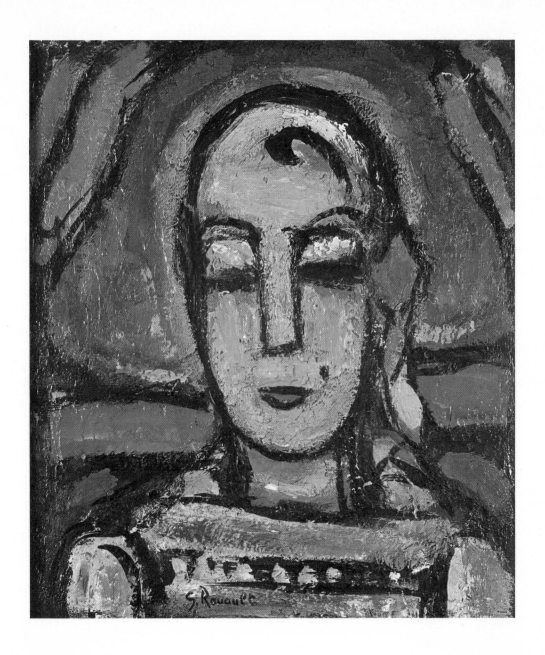

Georges Rouault
Pierrot
Oils on hardboard 14″ × 12″
Sonia Henie Collection, Oslo

Georges Rouault
The Holy Face, 1933
Oils on canvas 36″ × 26″
Musée National d'Art Moderne, Paris

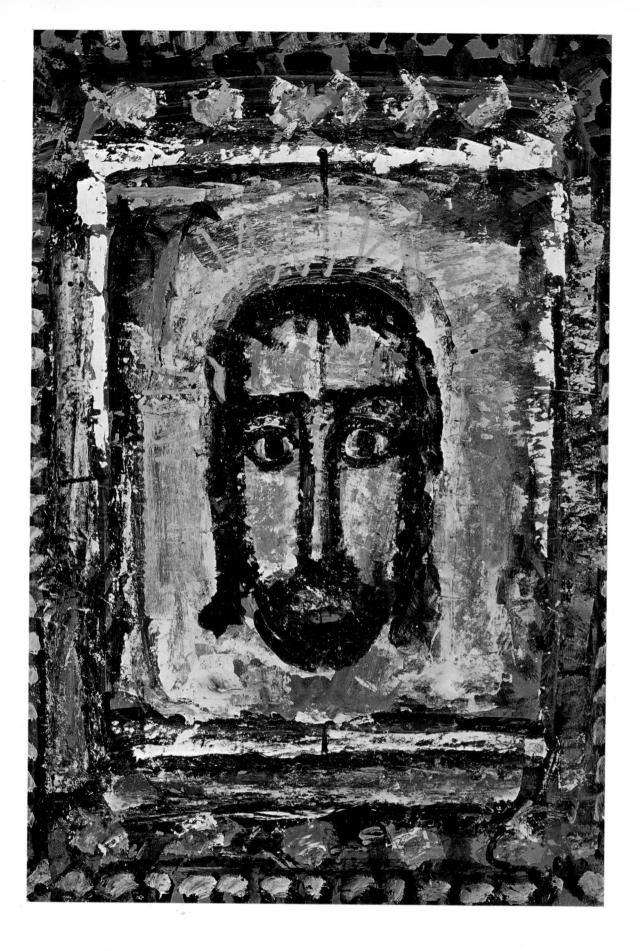

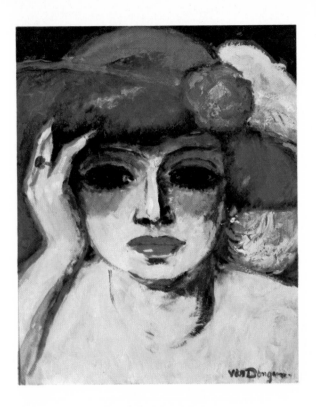

Kees Van Dongen
Fernande, 1903
Oils on canvas 22″ × 18″
In the artist's possession

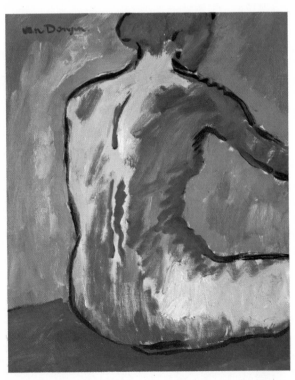

Kees Van Dongen
Back View of Seated Woman, 1905
Oils on canvas 22″ × 18″
In the artist's possession

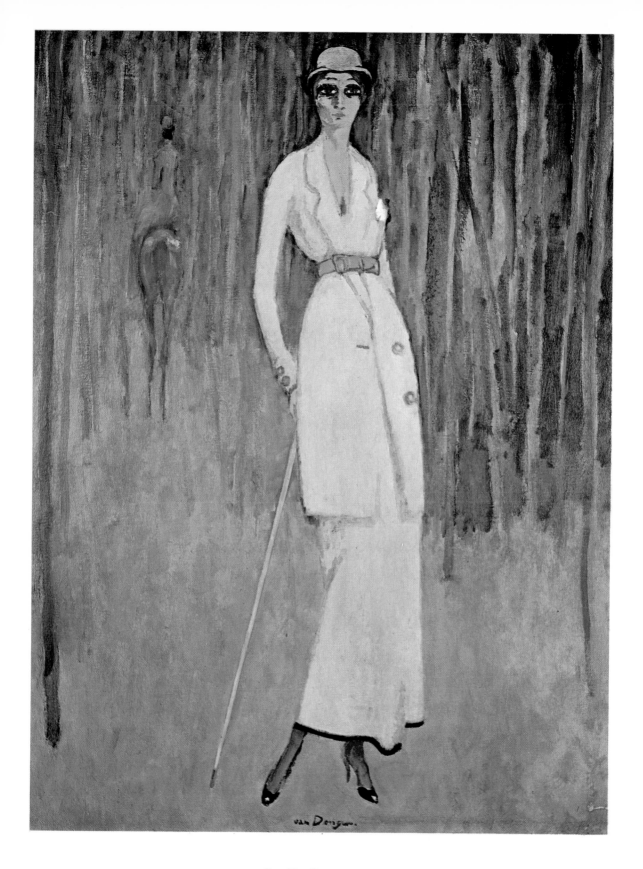

Kees Van Dongen
The Amazon, c. 1922
Oils on canvas
Private collection, Paris

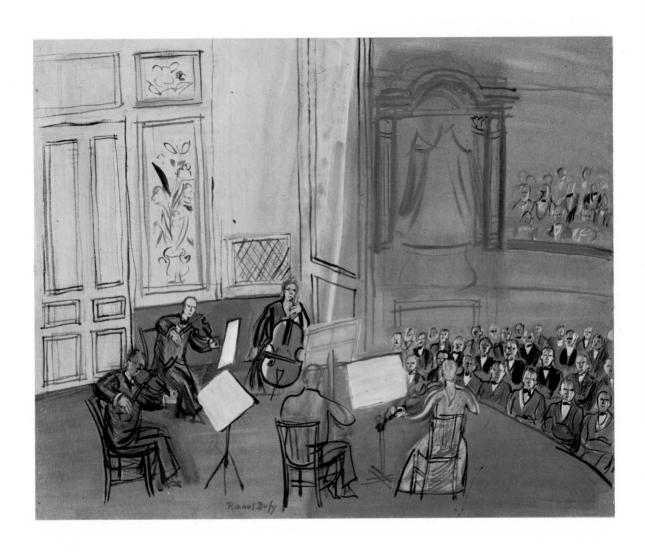

Raoul Dufy
Concert in Orange, 1948
Oils on canvas 24″ × 29″
Louis Carré Collection, Paris

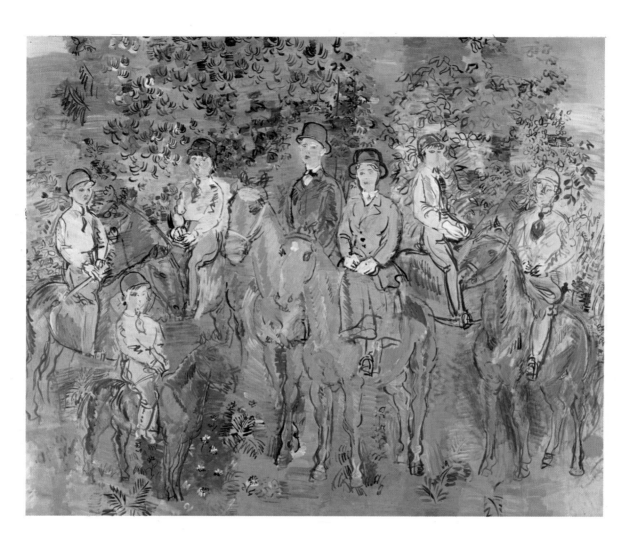

Raoul Dufy
The Riders under the Trees, 1931
First version of the portrait of J. B. Auguste Kessler
and his family on horseback
Musée National d'Art Moderne, Paris

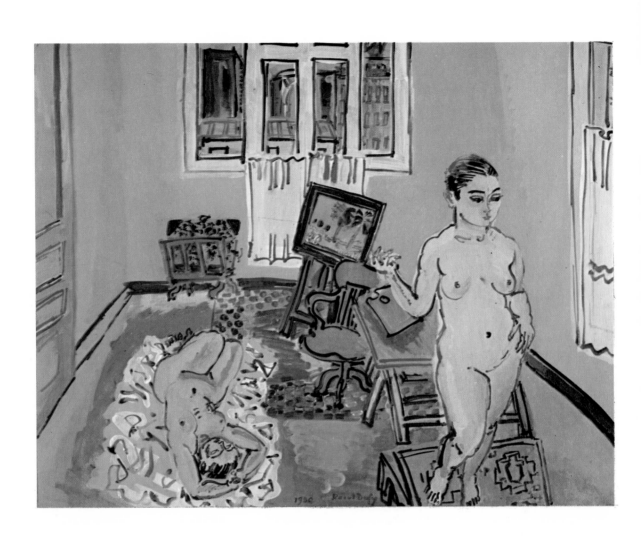

Raoul Dufy
Studio with Two Models, 1930
Oils on canvas 32″ × 39″
Mabille Collection, Brussels

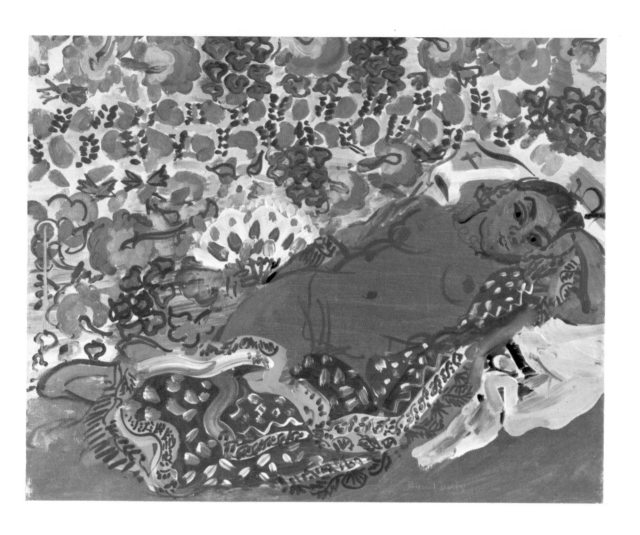

Raoul Dufy
Le Havre 1877-Forcalquier (Lower Alps) 1953
Indian Woman, 1928
Oils on canvas 18″ × 22″
Galerie Louis Carré, Paris

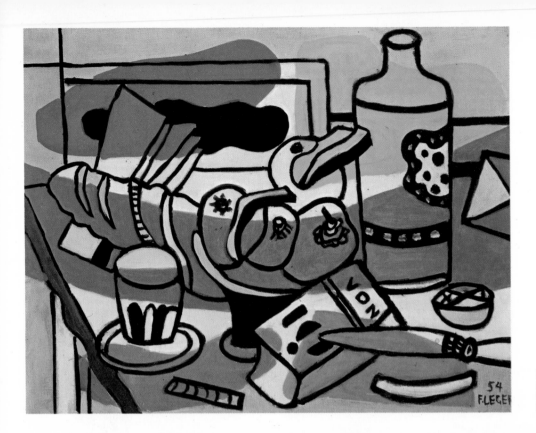

Fernand Léger
Still-life with Three Fruits, 195
Oils on canvas 20″ × 26″
Sonia Henie Collection, Oslo

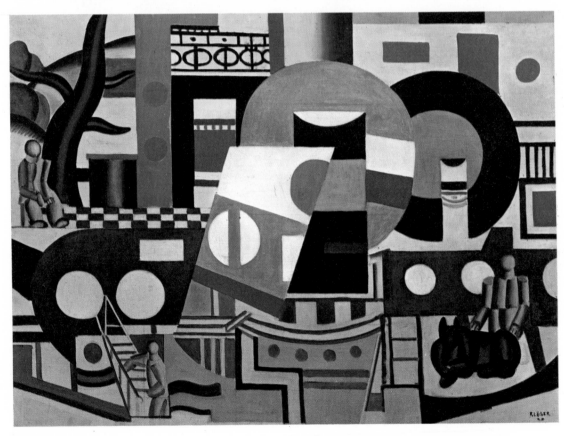

Fernand Léger
The Tug-Boat, 1920
Oils on canvas
Municipal Museum, Grenoble

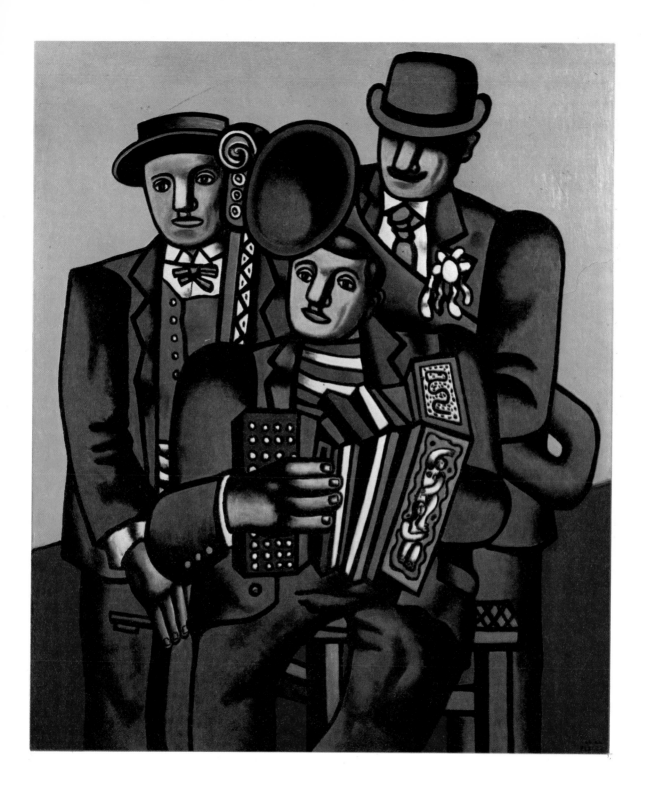

Fernand Léger
Three Musicians
Oils on canvas
Munich Museum

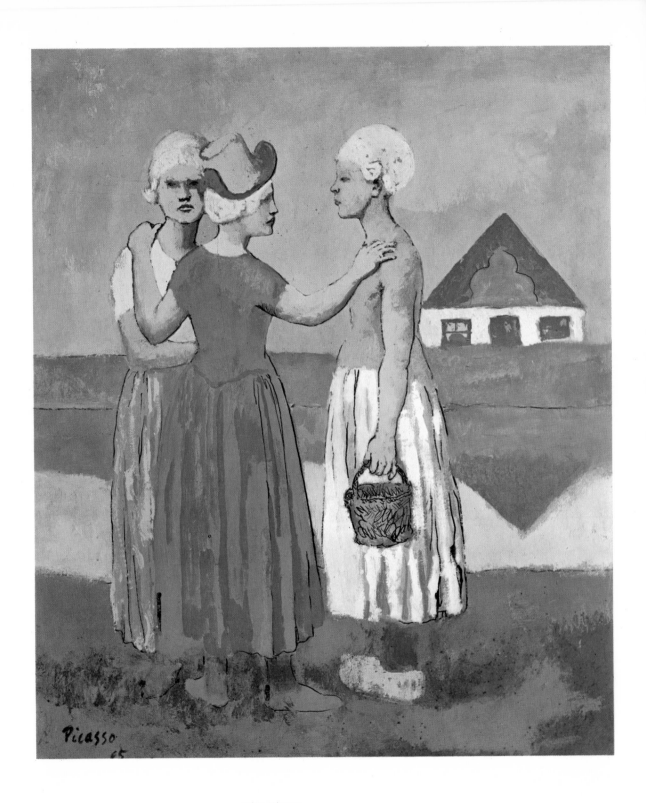

Pablo Picasso
Málaga 1881
Three Dutch Women, 1905
Oils on canvas
Musée National d'Art Moderne, Paris

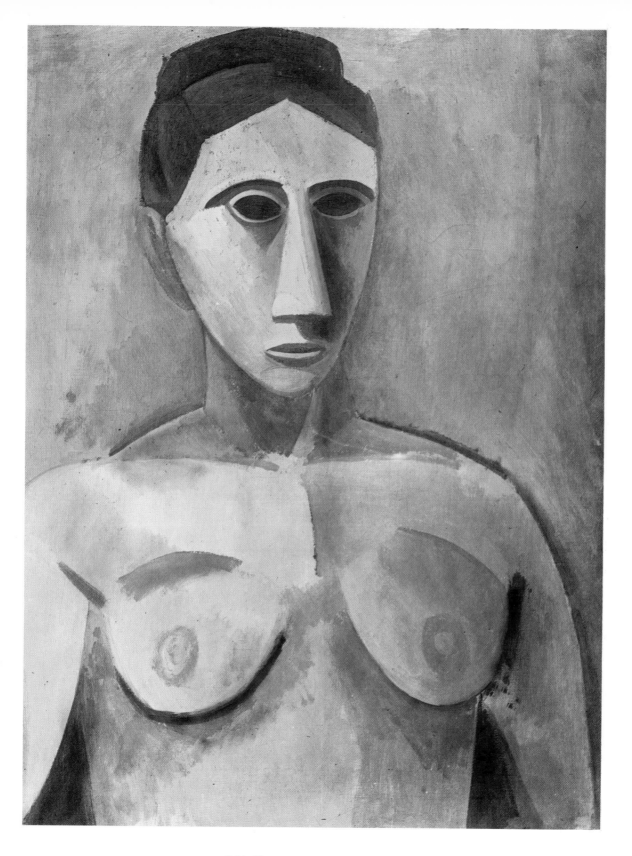

Pablo Picasso
Head and Shoulders of a Woman, 1907
Oils on canvas
National Gallery, Prague

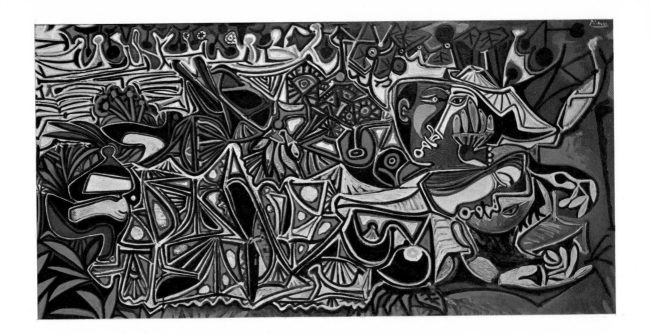

Pablo Picasso
Women on the Banks of the Seine, 1950
Oils on canvas 39″ × 79″
Kunstmuseum, Basle

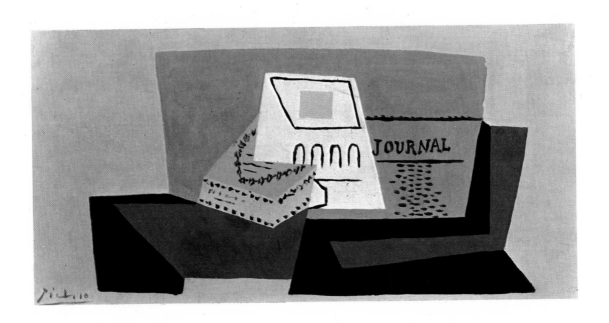

Pablo Picasso
Newspaper, Glass and Packet of Cigarettes
Oils on canvas
Private collection, Paris

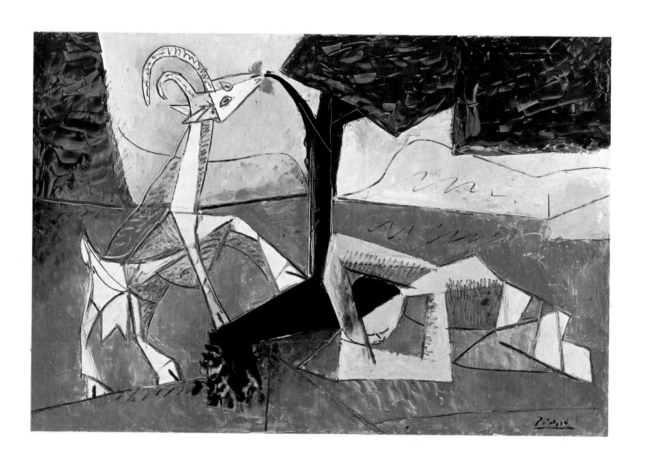

Pablo Picasso
Spring
Oils on canvas
Private collection, Paris

Georges Braque
The Port of Estaque, 1906
Oils on canvas
Musée National d'Art Moderne, Paris

Georges Braque
The Weeding Machine, 1961-1963
Oils on canvas 47″ × 69″
Louvre, Paris

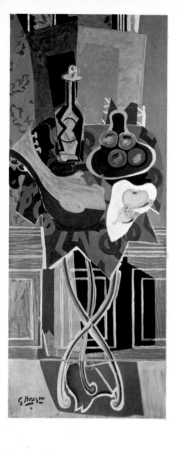

Georges Braque
The Round Table
Oils on canvas
Musée National d'Art Moderne,
Parıs

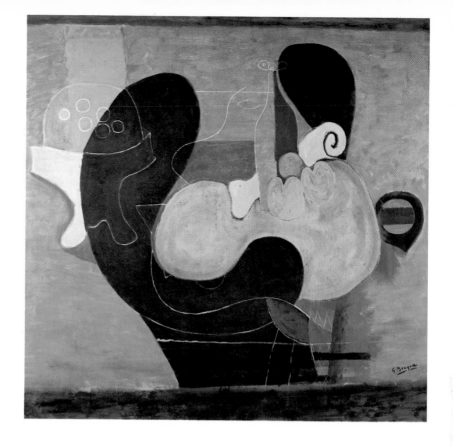

Georges Braque
Still-life, 1932
Oils on canvas
Musée National d'Art Moderne, Paris

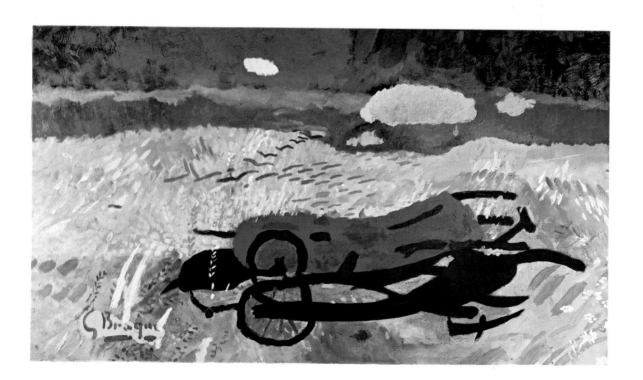

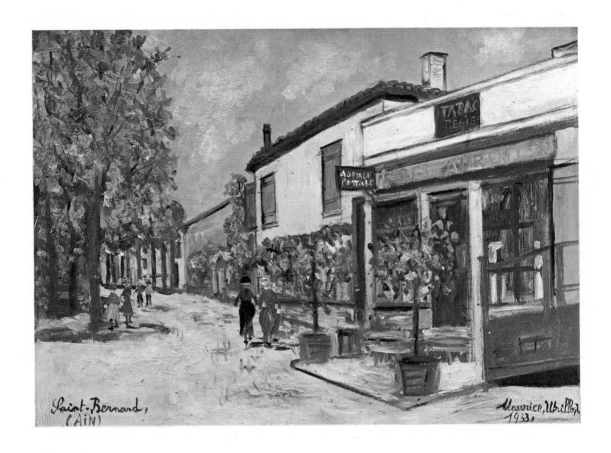

Maurice Utrillo
Montmartre 1883-Le Vésinet 1955
The Artist's House in the Country, 1933
Oils on canvas
Musée Fabre, Montpellier

Maurice Utrillo
Sacré-Cœur, 1948
Gouache 19″ × 13″
Museum of Art and History, Geneva

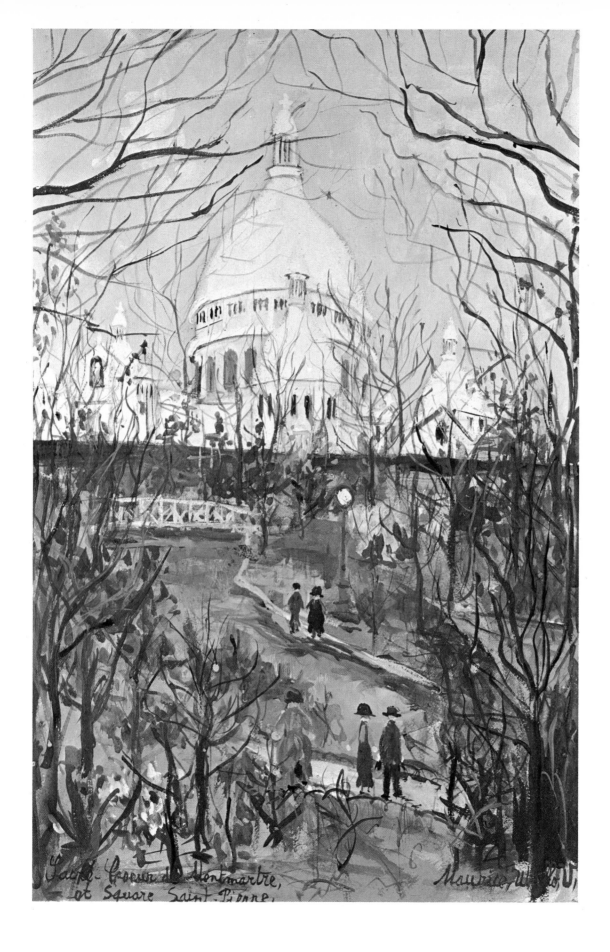

Sacré-Coeur de Montmartre,
et Square Saint-Pierre.

Maurice Utrillo, V.

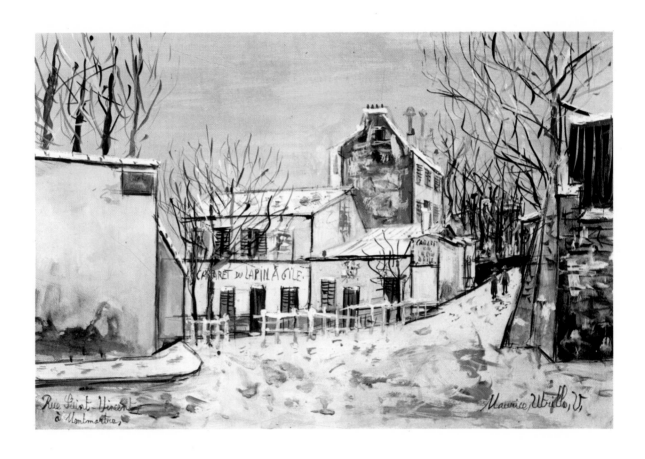

Maurice Utrillo
Rue Saint-Vincent, Montmartre, 1930
Gouache 20″ × 14″
Private collection, Geneva

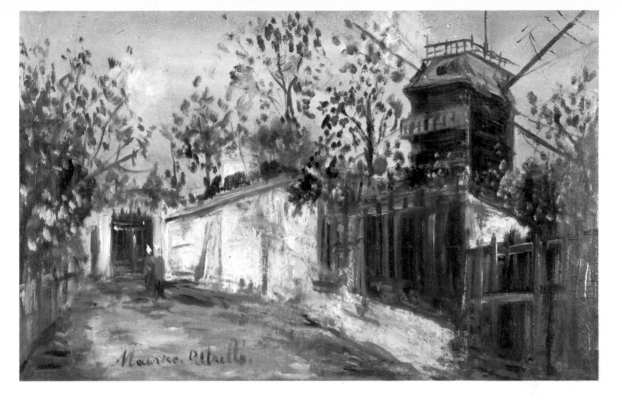

Maurice Utrillo
Le Moulin de la Galette, 1913-1915
Oils on canvas 11″ × 18″
Private collection, Villeret

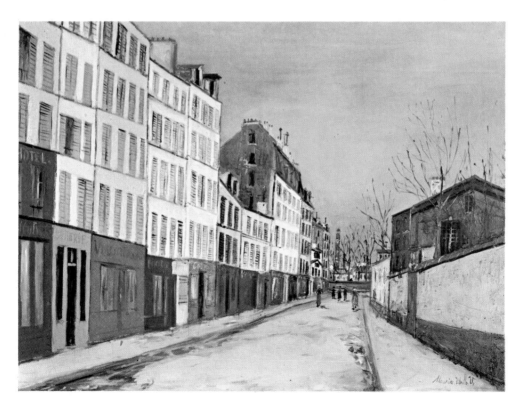

Maurice Utrillo
Rue des Poissonniers, 1930
Oils on canvas 37″ × 45″
Private collection, Paris

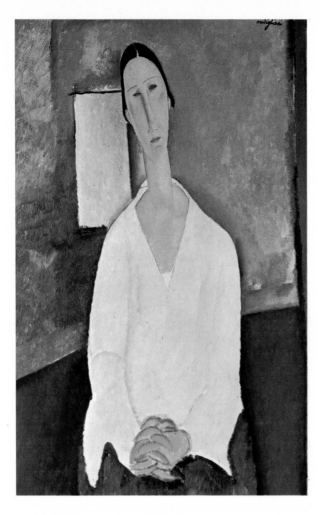

Amedeo Modigliani
Seated Nude
Oils on canvas
National Museum, Antw█

Amedeo Modigliani
Leghorn 1884-Paris 1920
Madame Zborowska with Clasped Hands, c. 1917
Oils on canvas
Private collection, Roubaix

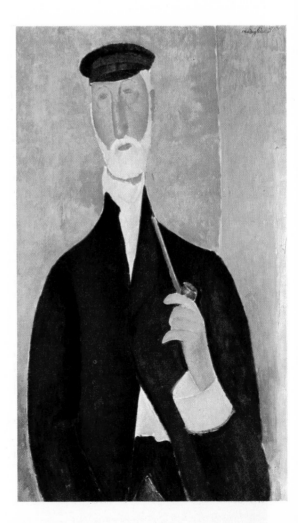

Amedeo Modigliani
Man from Nice, 1919
Oils on canvas 36″ × 24″
Masurel Collection, Paris

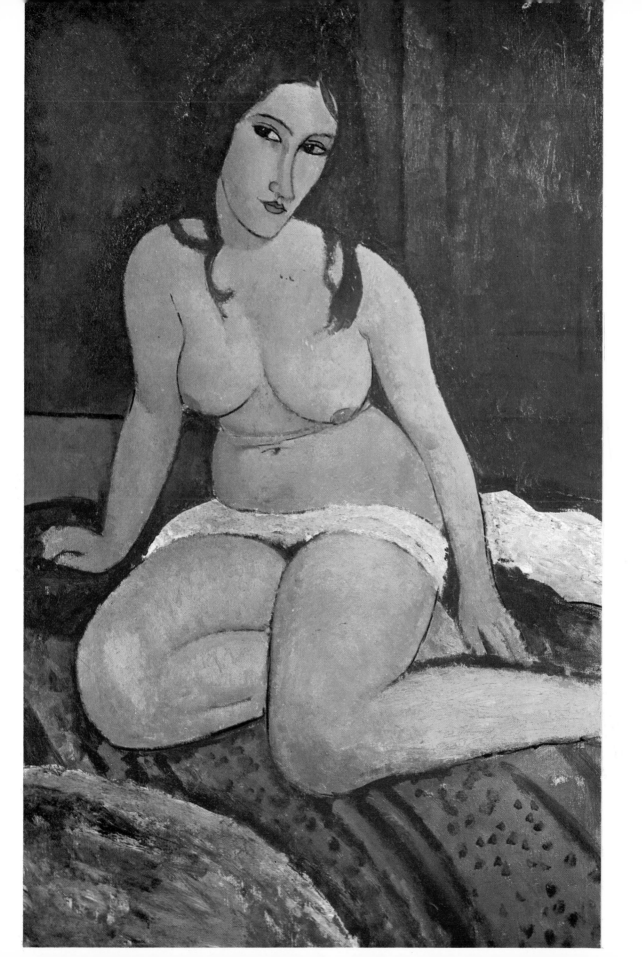

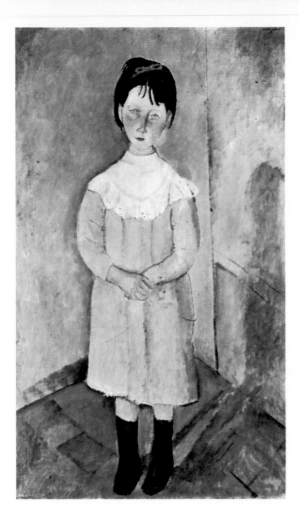

Georges Rouault
Paris 1871-1958
Clown, 1904
Oils on paper 29″ × 18″
Bayeler Gallery, Basle

Amedeo Modigliani
Little Girl in Blue
Oils on canvas 29″ × 46″
Mme Netter's collection, Paris

Amedeo Modigliani
Landscape
Oils on canvas 18″ × 22″
Mme Netter's collection, Paris

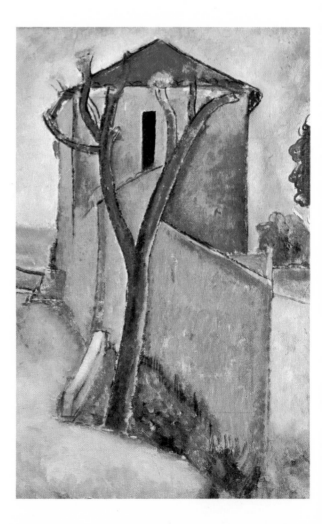

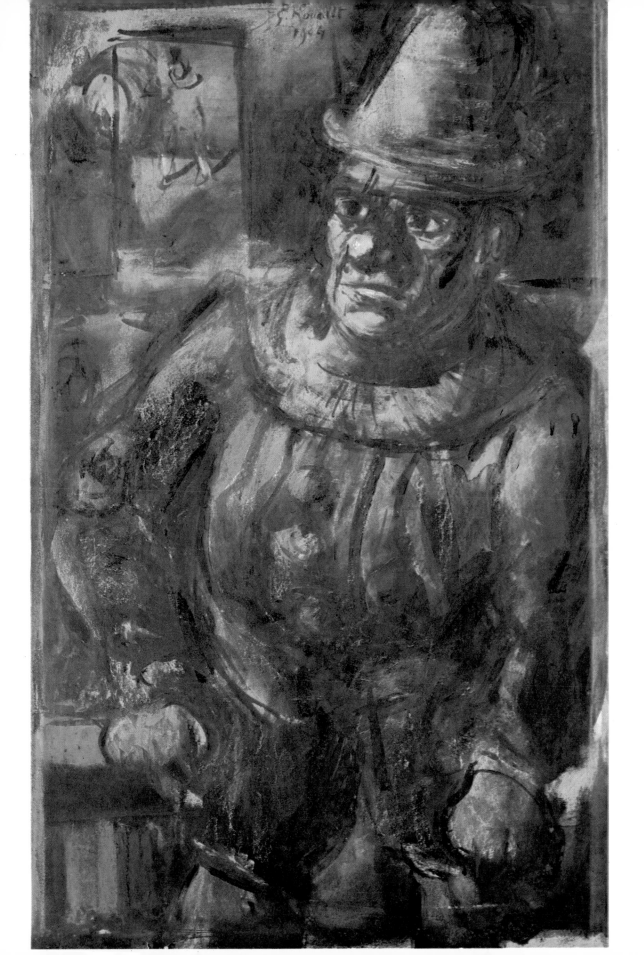

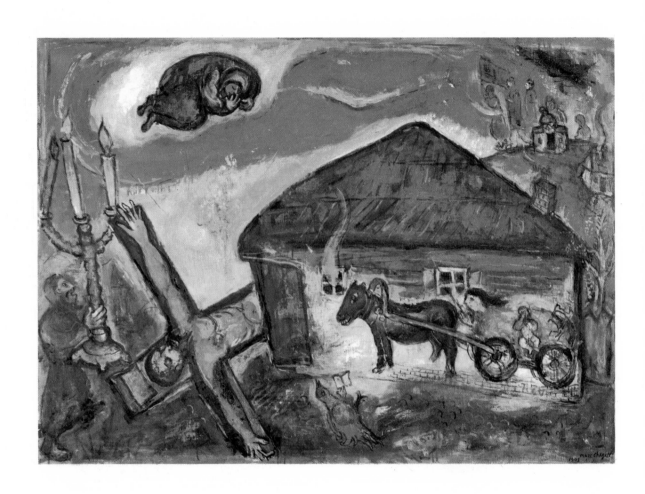

Marc Chagall
Obsession, 1943
Oils on canvas 30″ × 43″
In the artist's possession

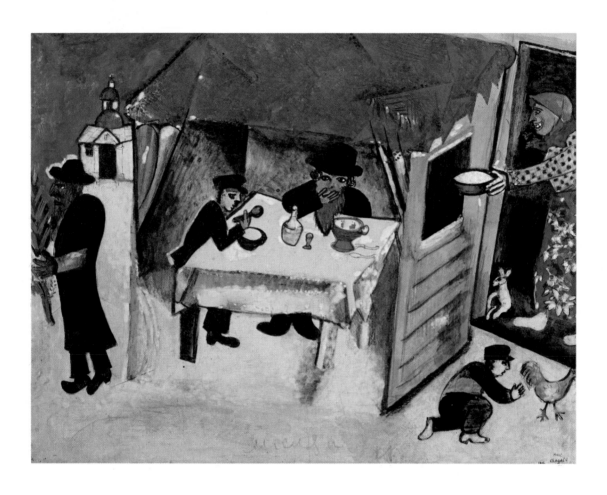

Marc Chagall
The Feast of Tabernacles, 1907-1918
Gouache on paper 13″ × 16″
Dr h.c. J. B. Belmont, Binningen

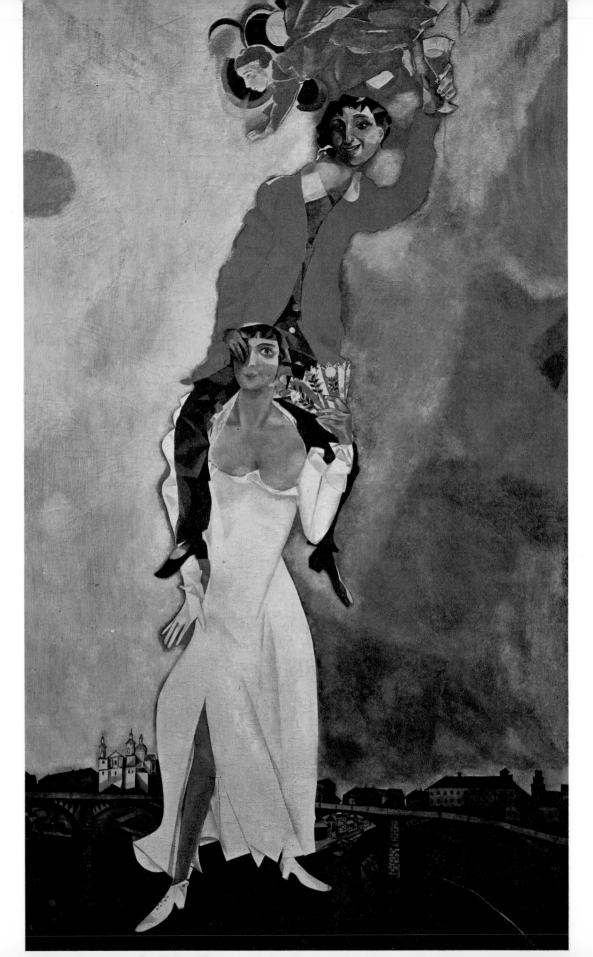

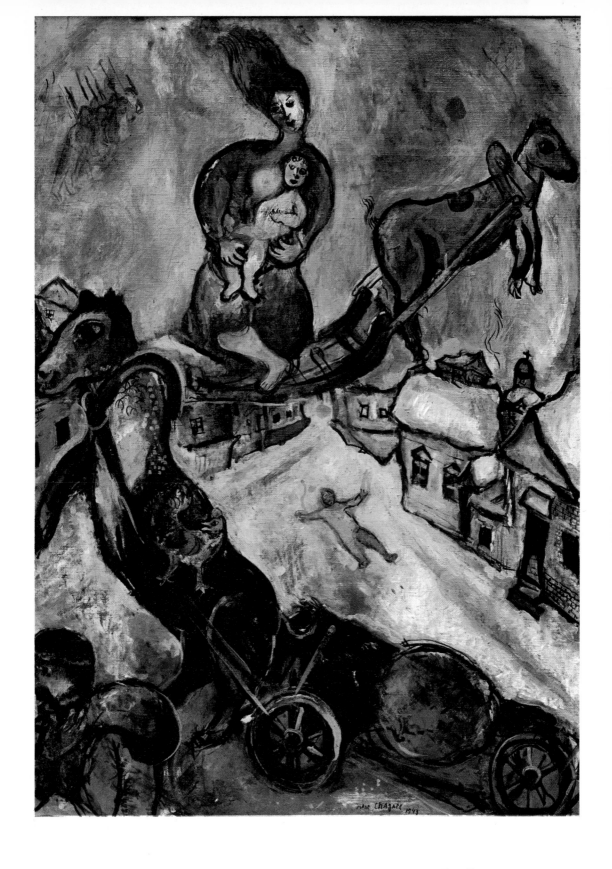

Chagall
Portrait with a Glass of Wine, 1917
canvas 92″ × 54″
National d'Art Moderne, Paris

Marc Chagall
War, 1943
Oils on canvas 41″ × 30″
Musée National d'Art Moderne, Paris

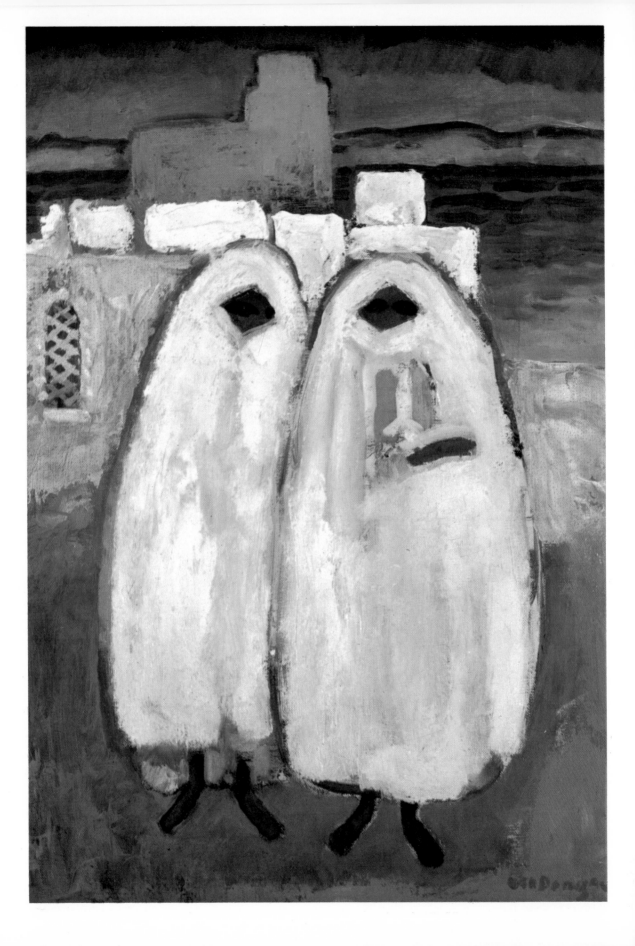

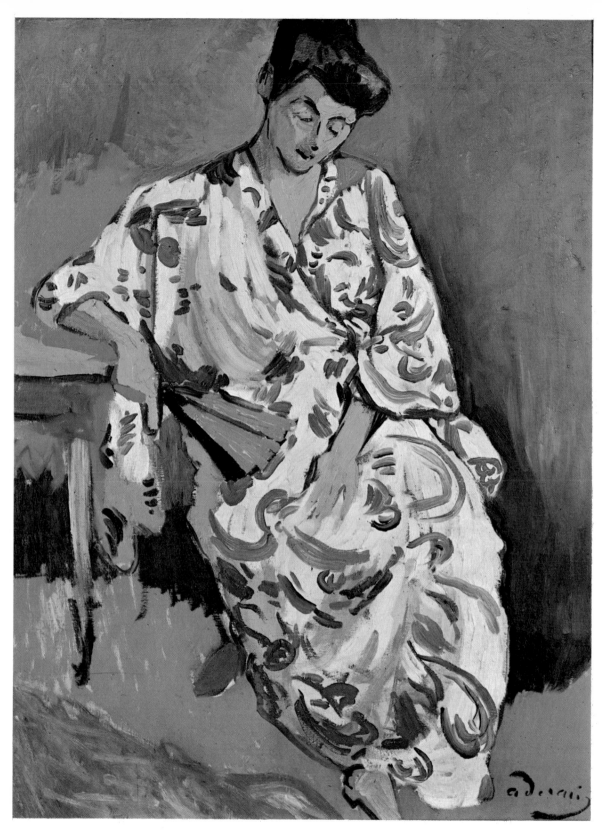

Kees Van Dongen
Delfshaven 1877-Monte Carlo 1968
Moroccan Women at Cap Spartel, 1910
Oils on canvas 22″ × 15″
In the artist's possession

André Derain
Chatou 1880-Garches 1954
Woman in a Shawl, 1908
Oils on canvas
Private collection, Paris

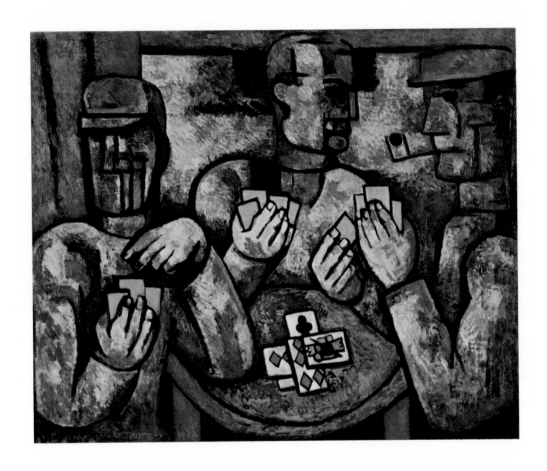

Marcel Gromaire
The Card Party, 1928
Oils on canvas 32″ × 39″
Pierre Lévy Collection, Troyes

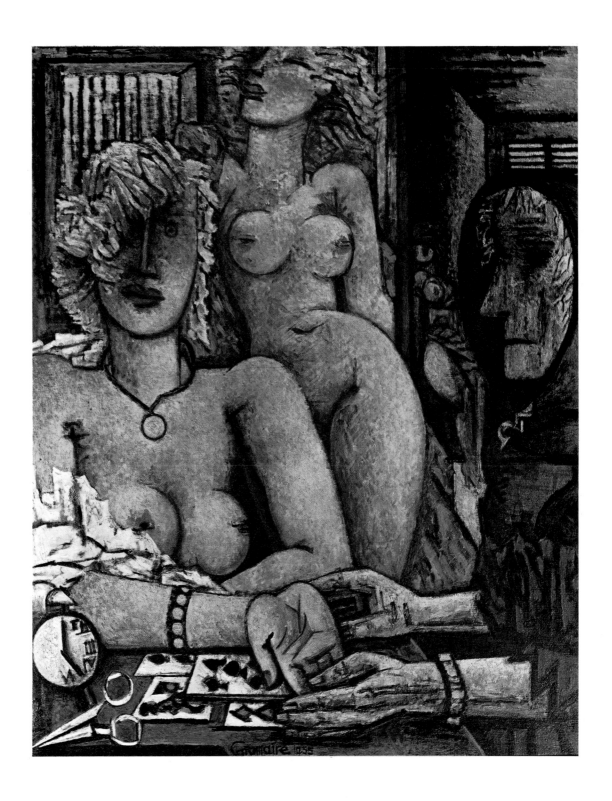

Marcel Gromaire
Noyelles-sur-Sambre (Nord) 1892
The Lines of the Hand, 1935
Oils on canvas 39″ × 32″
Musée National d'Art Moderne, Paris

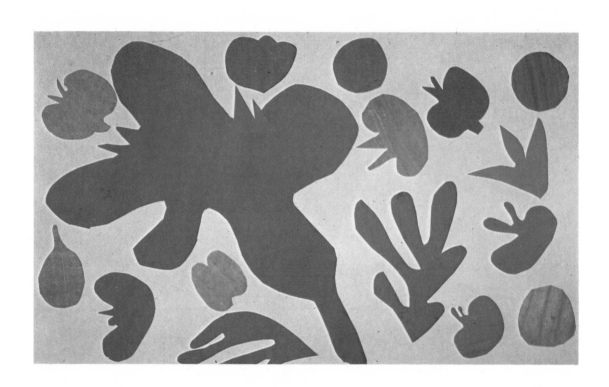

Henri Matisse
Corn Poppies, 1953
Gouache cut out and pasted 32″ × 135″
Matisse Family

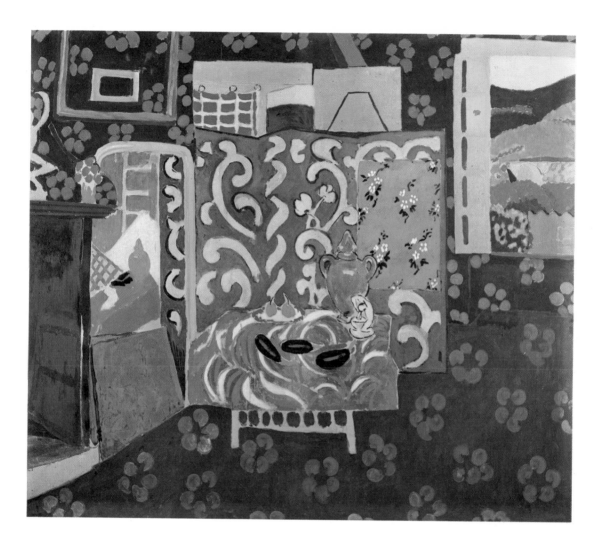

Henri Matisse
Interior with Aubergines
Oils on canvas
Grenoble Museum

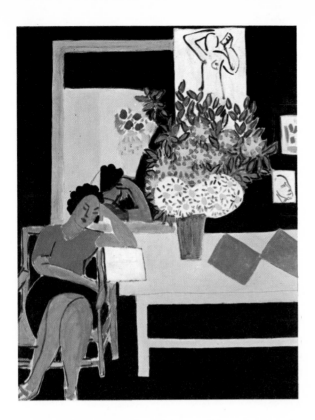

Henri Matisse
Woman Reading against a Black Background, 1939
Oils on canvas 36″ × 29″
Musée National d'Art Moderne, Paris

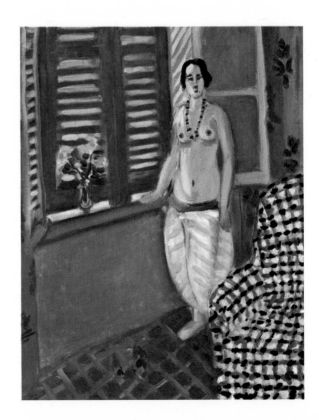

Henri Matisse
Odalisque with Blue Armchair, 1925
Oils on canvas 19″ × 15″
Bayeler Gallery, Basle

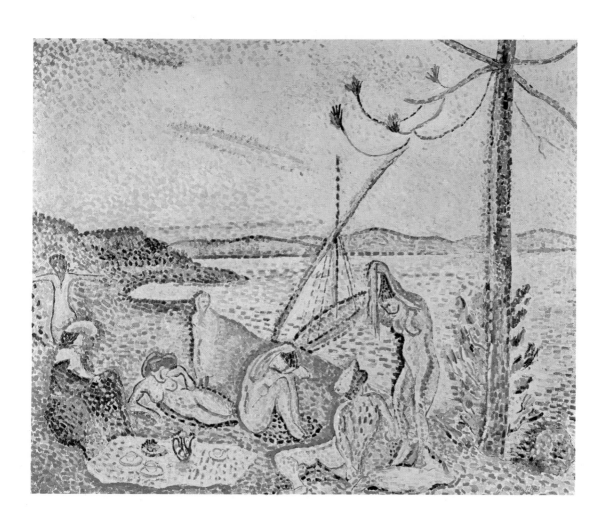

Henri Matisse
Luxe, Calme et Volupté, 1904
Oils on canvas 83″ × 55″
Private collection, Paris

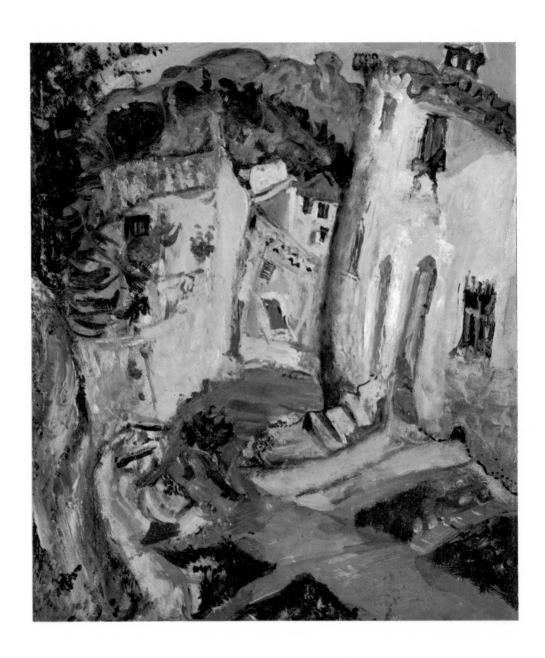

Chaim Soutine
The Red Flight of Steps at Cagnes
Oils on canvas 23″ × 19″
G. Waechter Collection, Geneva

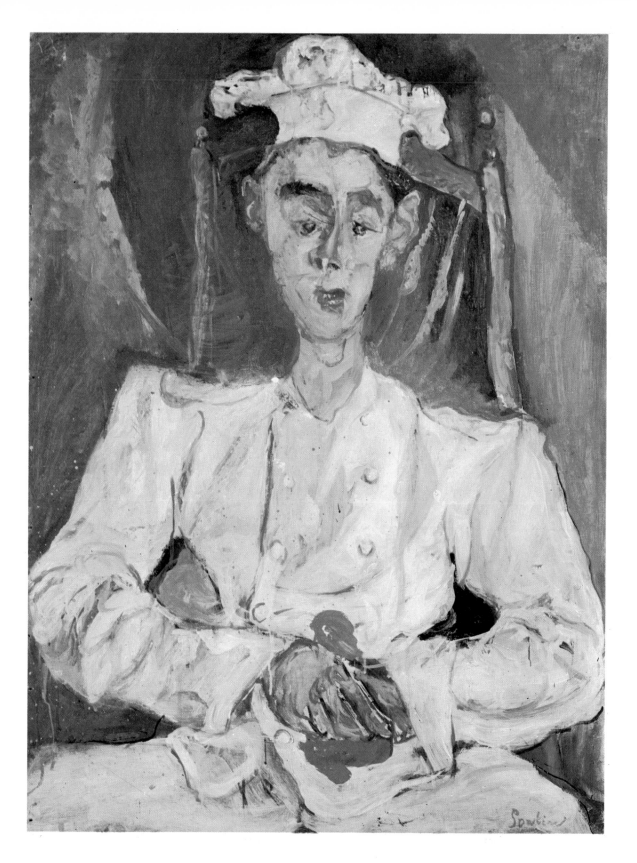

Chaim Soutine
The Pastrycook, 1922
Oils on canvas
Private collection, Paris

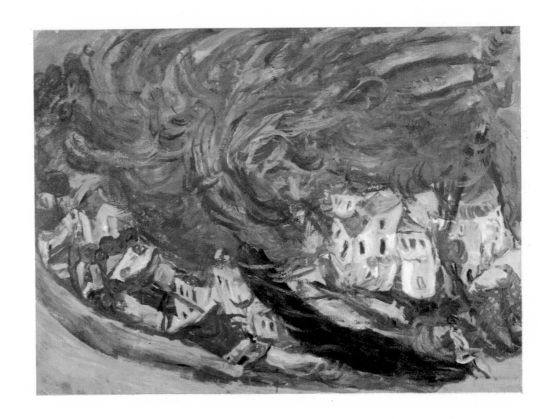

Chaim Soutine
Leaning Tree, 1922
Oils on canvas 26″ × 32″
Private collection, Paris

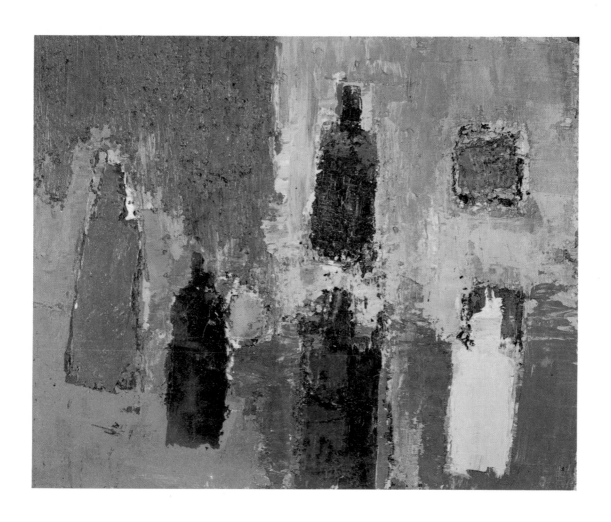

Nicolas de Staël
The Bottles
Oils on canvas 25″ × 30″
M. Buichard Collection, Berne

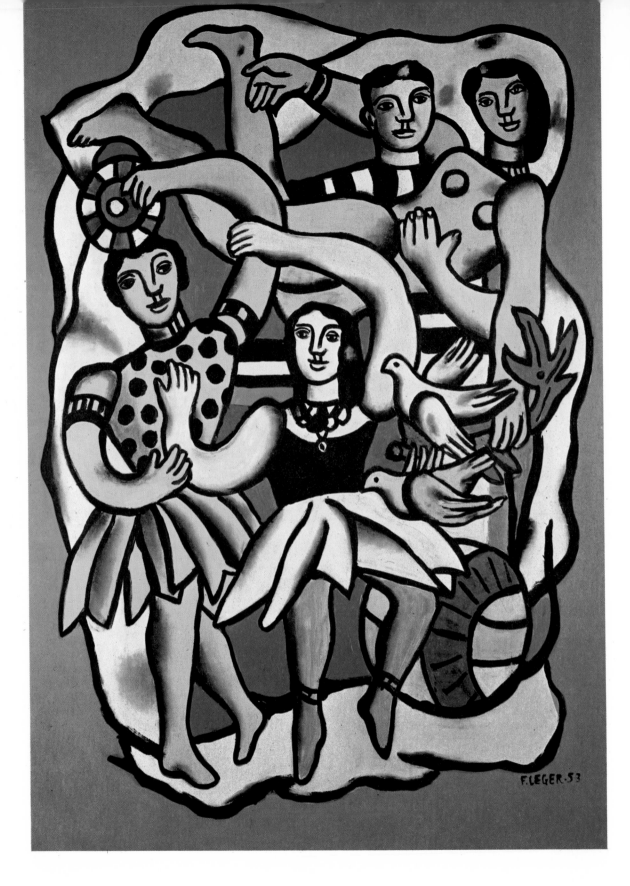

Fernand Léger
Dancers with Birds, 1953
Oils on canvas 52″ × 35″
Sonia Henie Collection, Oslo

Glossary of Modern Art

Abstract

Abstract art is most properly described as non-figurative art. In both painting and sculpture, all work which does not depict perceptible or visible shapes from the world around us, the objective world, is abstract. This loss of artistic interest in figurative images is generally attributed to the invention of photography. As Matisse said, "The painter need no longer concern himself with paltry details. Photography does it much better and more quickly." In fact, the birth of non-figurative art corresponds to a general development in all 20th-century modes of artistic expression: namely, to dispense with the anecdote in order to attain the essence, or, in other words, to pass from the temporal reality of the world to the metaphysical realism of existence. To this end, colours and lines are no longer used to depict the outside world, either by copying or interpreting. Endowed with psychic values, they become both entities in themselves and symbols identified with the phenomena of awareness and perception. The origins of non-figurative art could also be associated with the primitive sources of art. Nevertheless, Cézanne is generally agreed to be the initiator of this raw use of pictorial language, though it was not deliberately applied until 1910. It was in 1910, in fact, that the Russian Kandinsky, then leading the "Blaue Reiter" (Blue Rider) movement in Munich, began to paint his first Abstract works. He accompanied them simultaneously with a significantly entitled theoretical book, *Concerning the Spiritual in Art*, which remains the Bible of Abstract Art. Almost at once, numerous other artists from all corners of Europe adopted this way of seeing, understanding and creating: the French Robert and Sonia Delaunay, the Czech Kupka (1912), the Russian Larionov, Gontcharova and Malevitch (1913), and the Dutch Mondrian (1913). Two tendencies, however, were instantly discernible. One was colourful, lyrical, musically inspired, and engendered various more or less ephemeral movements: Musicalism (Kupka), Orphism (Delaunay) and Rayonism (Larionov and Gontcharova). The other was geometrical, more metaphysical in character, more instinctive, and took the form of Suprematism (Malevitch), Constructivism (Tatlin) and Neo-plasticism (Mondrian). These approximate or arbitrary denominations are quoted only as points of reference; other movements have continually succeeded them, and all may be formally reduced to the two tendencies mentioned above. Non-figurative art lost its experimental interest and creative power just before the second world war, but received a second wind from the war itself, and from the present and future menaces threatening the individual. Since 1962, it seems to have become immersed in developing the formulas of the last half-century.

Apollinaire, Guillaume (1880-1918)

His real name was Wilhelm Kostrowicki. French poet, born in Rome, died in Paris. The author of *Alcools* and *Calligrammes*, variously displaying relish, charm, vision or inventiveness, he was not solely one of the greatest French poets of the 20th century: his discoveries of young painters of his time and the support he gave them is greatly to his credit. He was twenty-two

when he published his first articles on art in *L'Européen*. After that he was constantly associated with all the great movements at the start of this century. First came Fauvism in 1904, then Cubism, which he defended publicly well before his book, *Peintres Cubistes*, came out in 1913. Meanwhile he discovered Picasso: his first article on the Catalan painter is dated 16 May 1905. He was also friend and publicist to Robert Delaunay (for whose painting he invented the term Orphism), Giorgio de Chirico and the Italian Futurists. He was also in at the start of Surrealism. Apollinaire did not base his active and discriminating participation in the artistic life of his period on any sort of bias towards modernism or the *avant-garde*. He was simply one of those rare people who had the gift of turning his wide and deep culture not into a reassuring or nostalgic refuge, but into a rapture of creative originality and an inexhaustible appetite for the future.

Buffet, Bernard (b. 1928)

French painter, born in Paris. Entered the Ecole des Beaux-Arts in 1944 but stayed only a short time. His limited colour-range, his Expressionism, which is either gloomy (emaciated people, empty or desolate landscapes) or terrifying (insects, giant birds, gaunt portraits), and his dry, acid style have secured him undiminished, world-wide fame since 1945.

Cubism

An aesthetic movement born about 1907 from the encounter of two influences, Cézanne, with his structural and conceptual breakdown of colour and light, and the primitive arts with their instinctive breakdown of form and line. It was promoted by Picasso and Braque. The first-fruits of this new pictorial language are generally agreed to be the former's *Les Demoiselles d'Avignon*, 1907, and the latter's *Paysages de l'Estaque*, 1908. The movement was fully rounded out by Matisse and Derain, followed by Juan Gris and Léger. Cubism should also be regarded as a reaction against Impressionism and Fauvism, that is to say, against the excessive domination of colour alone. Cubism's contributions and methods include geometric configuration of the canvas, simultaneous depiction of the multiple facets of a solid shape which is thus deployed on the two-dimensional surface of the canvas, and emphasis on the architecture and essential rhythm of the things depicted. All at once objects became its subjects of choice in preference to landscape or human figures, still-life being the favourite genre. After a Cézanne period, Cubism went through two phases: analytical (1910-1912), then synthetical (1913-1914), the first being the province of Picasso and Braque, the second of Juan Gris and Léger. The first book devoted to Cubism was the work of its initiates, Gleizes and Metzinger.

Domergue, Jean-Gabriel (1889-1962)

French painter, born in Bordeaux. He attended the Académie Julian and won the Prix de Rome at the age of eighteen. Worldly and snobbish, he specialised in languid and sophisticated nudes of current celebrities. In 1927 he settled in the famous Villa Fiesole in Cannes, and eventually bequeathed it to the town. He was a member of the Institute, and in 1955 he was appointed custodian of the Musée Jacquemart-André, where he organised some important exhibitions (Van Gogh, Lautrec, etc.).

Duchamp, Marcel (1887-1968)

French painter, born in Blainville. Younger brother of Jacques Villon and Raymond Duchamp-Villon. He worked first as librarian in Paris. In 1911 he revealed himself in a surprising way, neither the teaching he received at the Académie Julian nor the early Fauve and Impressionist canvases predicting his sudden analytical style. Two years later he left Europe, which was too traditionalist for his liking. His contribution to the New York Armory Show with his sensational canvas *Nude Descending a Staircase* made him famous, but neither success nor the offers that beset him could deflect him from his path. He earned a living by giving French lessons. His meeting with Picabia and Man Ray in the United States was the origin of a movement which, in many ways, heralded Dadaism. This undoubtedly gave him the desire to go back to Europe where Dada was flourishing after the first world war. He also took part in the Surrealist movement until 1925. His work then falls into two categories: first, painting—a combination of Cubism, Futurism and Surrealism, its chief realisation being *The Bride Stripped Bare by her Bachelors, Even* (1915-23); second, the "readymades". As their name indicates, these were simply practical objects (a bottle-rack, a urinal) given the function of *objets d'art* by being exhibited as such, with occasional minimal alterations. This aspect of Marcel Duchamp's creative imagination did most to win him fame. He gave ceaseless inspiration to Europe an and American artists and was the uncontested father of Pop Art. Marcel Duchamp's singularity was, however, mainly of an ethical nature, for, determined not to be ensnared by his own inventions, he maintained his freedom by abandoning each as soon as begun. After 1938, the date of the Paris Surrealist exhibition, he dropped out of artistic life. He lived permanently in New York until his death on 1 October 1968.

Expressionism

Expressionism does not exist in time and space; it belongs with the means, methods and manners of artistic creation and of man's whole history. In painting, it consists in externalising, sometimes exaggerating, psychic, emotional and subjective manifestations to which it is desired to give a dramatic or painful turn. In this sense, caricature, anecdotal distortion, the exaggeration of colour or design and the morbid or passionate romanticism of subjects naturally forms part of the method. In the modern period, the word Expressionism is always applied to a movement of German and Nordic origin and location. Its source springs from Van Gogh (and partly from Toulouse-Lautrec). Then came the Norwegian Edvard Munch and the Anglo-Flemish James Ensor. These were the artists who gave the revelation of their style and their universe to the German painters of the "*Brücke*" (Bridge) group which appeared in 1905. Nolde and Kirchner were its best representatives. To a certain extent, the "*Blaue Reiter*", which took over from "*Die Brücke*", also belonged to German Expressionism, but it evolved fairly quickly in a more intellectual direction. The Austrian Kokoschka and certain painters of the Paris school (Soutine, Chagall and Pascin) should also be linked with the Expressionism of that period and mood. The Latins have subscribed equally to the methods of Expressionism. Everything has invited them to do so in the world's permanent state of crisis, disturbance and danger since the first world war: in France, Rouault and, to a lesser degree, Gromaire and Picasso (notably in *Guernica*); in Mexico, Rivera, Orozco, Siquieros and Tamayo. The movement crossed the border-lines of the plastic arts and

affected literature, theatre and cinema, notably in Germany in the 1920s.

Fauvism

French artistic movement, springing from the conjunction of two influences: that of Van Gogh (for pure, violent colour and the Expressionist style) and that of Cézanne (for structure, the value of balance and the cult of light). Both these influences overlapped in their separation of colour from anecdote—the subject of the picture. Georges Seurat and Paul Gauguin also have claims to the fatherhood of the movement. Fauvism was in gestation from 1900, but it was effectively and officially born at the Salon d'Automme, 1905. It was there, in fact, that the three founder-groups met for the first time: that of Matisse, coming from Gustave Moreau's studio (Marquet, Manguin and Camoin), that from Le Havre (Dufy, Friesz and, the following year, Braque), and finally the two friends from Chatou (Derain and Vlaminck). The names of Van Dongen and Rouault should also be added, as independent spirits who did their first true work with the same energy and the same love of pure colour. The ephemeral existence of Fauvism—it disintegrated after 1907—can be explained by the unusual state of tension and emotional involvement it demanded of its adherents. Derain defined it as an *auto-da-fé*. It was a trial in which French painting found its finest and most intense flame of passion, purity and daring. The emulation it provoked literally wrested their best works from several artists who could never again recapture the same fervour and brilliance: Marquet, Puy, Valtat, Camoin, Manguin, Chabaud, Friesz and, without doubt, Dufy and Vlaminck also.

Ferrier, Gabriel (1847-1914)

French painter, born in Nîmes, died in Paris. Prix de Rome 1872. Became a teacher at the Académie des Beaux-Arts in 1906. His work, thoroughly imbued with the period's conventional aesthetics, lacks vigour. Noteworthy, however, are *Women Smoking Indian Hemp* and *The Martyrdom of St Agnes*, now in the Rouen Museum, and the ceiling decoration in the Nîmes theatre foyer.

Futurism

Movement of Italian origin which attempted to introduce the mechanical, dynamic and energetic attributes of modern civilisation into painting, equating them with spiritual and artistic qualities. The birth of Futurism is dated from the manifesto by the poet F. T. Marinetti, published in *Le Figaro* of 20 February 1909. This manifesto, violently polemic, contained affirmations which have since become familiar sayings: "A racing-car is more beautiful than the *Victory of Samathrace*", or "Long live the action of killing", or "Art can be only violence, cruelty and injustice". In actual fact, Futurism was partly a reaction against the excessively static form within which Cubism confined painting, and partly against Italy's current state of social, political and intellectual stagnation. The first and principal members were Carrà, Boccioni, Russolo, Balla and Severini. Futurism's activities rapidly extended to theatre, poetry and music; but it had the brevity of its own violence. The death, in 1916, of its theorist and most talented creator, Boccioni, at the age of thirty-four, brought about its dispersal.

Giacometti, Alberto (1901-1966)

Swiss painter and sculptor, born in Stampa. He studied in Geneva, then Rome. From 1925 to 1928 he was interested in "object-sculpture". In 1930 he

was attracted by the Surrealist movement, but his independence and solitariness soon made him diverge. From 1935 onwards the human form absorbed all his attention and stimulated all his inspiration. He made numerous characters and portraits in an agonised, filiform, Expressionist style, animated by two major preoccupations: one, the suggestion of infinite space surrounding humanity's precarious presence; two, the expression of the terror inherent in all flesh and constantly revealing the primitive man within us.

Grüber, Francis (1912-1948)

Since its beginning, French painting has gone through a series of pendulum movements which for a long time assured its equilibrium. (Only in the last twenty years has the triumph of non-figurative art made a break with the tradition of each generation reacting against the one preceding.) Thus the Cubists' intellectual exercises and their constructive and decorative interests were opposed, about 1935, by a group of young artists devoted to the strict observation of reality. The most categorical of those united under the banner of " New Forces " were Robert Humblot, Georges Rohner and Henri Jannot, who were joined by Civet, Despierre, Tailleux and Vénard, and although Francis Grüber always remained fiercely independent, he worked along the same lines. René Huyghe wrote of Grüber's drawing that it was " abrupt, brittle, angular, jerky. He bristles with points like barbed wire and hacks indentations like sharp splinters of glass, drawing unprecedented in France. This aggressive, dislocated style, expressing an almost cruel tension, is found expanded in Germany in the crooks, jerks and scratches of Dürer, Wolf Hüber and Grünewald." He goes on to ask, " Under the impact of what moral shock, what obsessions, what upsetting of

life, what monstrous circumstances, what surrounding cruelty, would French graphic art renounce its familiar inflexions and be carried away by this compelling fever?"

To answer this question, it is necessary to go back to the perilous pre-war years and consider the actual life of Francis Grüber. He was born in Nancy on 15 March 1912; his mother came from Poland, and his father, a painter-glazier and Nancy schoolmaster, from Lorraine. He spent most of his life in Montparnasse, in the Passage d'Alésia, where his father, assisted by his brother, had his studio. In these surroundings the child began to draw very early. He suffered terrible bouts of asthma, so drawing became a diversion for him, and, being unable to attend school regularly, he frequented neighbouring studios, that of Braque and that of Bissière, who encouraged and advised him. In 1928 he entered the Académie Scandinave, where Waroquier, Dufresne and Friesz were teaching. Friesz had the greatest influence on him and at the end of his life Friesz's young pupils, Cortot in particular, recognised him as a master. Grüber's strong personality rapidly emerged. Made hypersensitive by illness, and becoming the master of a very firm technique, he interpreted in his works the anguished world about him. He revived Expressionism with an acute analysis of reality, concentrating particularly on the nude. He used emaciated models, posed in the glaucous light of his studio in the Passage d'Alésia. He was a very individual colourist, cleverly using touches of dramatic red to relieve his monochrome canvases dominated by grey and green. His ambition led him towards large-scale composition. He decorated the Lycée Lakanal and, at the height of the war, his *Homage to Jacques Callot* was at once a cry of love for Lorraine and a protest against the occupation of his country. The Germans were not blind: they would not authorise the picture to be shown until the painter had

erased the blue-white-and-red flowers in the martyred woman's hand. When very young, Grüber went with his brother to Belgium, where he discovered Bosch and Brueghel and was particularly struck by the altar screen of *The Mystic Lamb* in Saint-Bavon's, Ghent. He was attracted by such German masters as Altdorfer, and realised the need for order and internal organisation of pictures; he profoundly admired Louis David. He rapidly became prominent with his intelligence, strong personality, sharp wit and culture which he owed solely to himself. At the age of eighteen, when his elders founded the Salon des Tuileries, he was one of their first guests. In 1942 he succeeded Bissière as a teacher at the Académie Ranson. Before the war his canvases had been rarely seen except in the modest galleries on the left bank, but during the Occupation art-lovers and critics no longer doubted that, at the age of thirty, he was the master of realistic fantasy. His large exhibition in 1945 established him firmly. But a highly active, irregular life increasingly aggravated his already deficient health, which soon interfered with his work. His style remained firm and his expression vigorous, but he could work for only a few hours a day; it was a poignant spectacle to see this still-young man climbing out of bed, irresistibly drawn towards the half-finished canvas. His style became more intense, more economical. He relinquished none of his ambitions, as witness his *Job* painted in 1944. He spent a long time over his pictures never hesitating to destroy any which did not entirely satisfy him, and his work remains the most striking testimony left to us by a terrible period. In 1947 he was ultimately rewarded with the Grand Prix National, but he died on 1 December 1948. So much for the curtailed work by a man whose premature death still leaves a painful gap in the development of French painting. (G. Ch.)

Kokoschka, Oskar (b. 1886)

Austrian painter, born in Pöchlarn, Austria, on 1 March 1886. He went to Vienna and studied at the School of Arts and Crafts from 1905 to 1909, shortly afterwards being appointed a teacher there. Moving in artistic and literary circles in the Imperial capital, he painted numerous portraits of actors and writers, developing a tormented and visionary Expressionist style, at the same time writing for the *avant-garde* Berlin magazine, *Der Sturm*. From 1910 to 1914 he divided his activities between Berlin and Vienna. His meeting with Alma Schindler, the widow of the composer Mahler, inspired him to one of his masterpieces, *The Bride of the Wind* (1912). In 1915 he was seriously wounded in the war and went to live in Dresden, where he taught at the Academy until 1924, at which time he started travelling about Europe, North Africa and the Near East. He returned to Vienna, but when Chancellor Dollfuss was assassinated he left again and went to Prague. In Germany, 427 of his canvases were confiscated as " degenerate art ". After Munich, he reached London, and acquired British nationality in 1947. The war inspired him to paint combat pictures and political allegories against the Nazi horror. Since 1955 he has resided in Switzerland, continuing his pictorial experiments and giving remarkable teaching at the summer-school run by the Salzburg Academy of Fine Arts.

La Fresnaye, Roger de (1885-1925)

A number of painters who fought in the first world war died prematurely, and among them was Roger de La Fresnaye; he never recovered from the tuberculosis he contracted in the army and spent his last years in Grasse, where he died on 27 November 1925. Both his origins and his

tastes seemed to predestine him to join Dunoyer de Segonzac's group of friends. His intellectual curiosity led him to the Cubists. However, by the end of his all too short life he had developed a precise style which can be described as Mannerist. These fluctuations appear normal in an artist who was not averse to the movements of his period and wished to master them. His childhood drawings revealed a precocious ability and he met with no resistance when, in 1903, he decided to enrol at the Académie Julian. He was then eighteen, having been born in Mans on 11 July 1885. The Académie Julian has played a major role in the development of contemporary painting. At the time when Roger de La Fresnaye was emerging, one of the "massiers" (students in charge of funds) was Paul Sérusier, who had not yet received the revelation of the *Talisman*, painted by Sérusier with Gauguin's advice in 1888, but who was already exercising his influence over the young painters who were to become known as Les Nabis: Bonnard, Vuillard, Roussel, Maurice Denis, Redon and Vallotton were all pupils at the Académie. After these pioneers, a new generation of innovators preferred these independent studios to those of the Ecole des Beaux-Arts: Segonzac, Lotiron, Moreau, Boussingault, etc. These were La Fresnaye's first friends in the world of painters. The Julian spirit had also touched the Académie Ranson, where Maurice Denis was teaching; La Fresnaye enrolled at his studio and, during the years 1908-1909, came strongly under his influence. Like all the best of his generation, he was touched by Cézanne's grace, and *The Cuirassier*, which he exhibited at the Indépendants in 1911, shows how rapid his development had been. He was at first attracted to boldly simplified forms, but his Cubism soon diverged radically from that of Picasso, the Orphists or the Puteaux group. He employed an entirely personal style, solidly grafted on to reality. He and

Delaunay and Léger alone were interested in their period: although he was not satisfied with the abstract solutions to the problem of composition these two artists suggested, he shared their liking for colour, and his large canvases are accented with some very bright touches. He was already in control of a firm technique; he owed his natural superiority to his upbringing in an aristocratic background and a refusal to be absorbed into any one of a number of movements which would gladly have welcomed him. He liked architectural shapes and striking, but not simplified, compositions, and in his intense output of the years 1911-1914 can be found the primers of many experiments attempted after the war by dissidents from Cubism. The visit he made to Germany in 1910 allowed him to escape from the theories then confronting each other in Paris studios and enabled him to take stock, which resulted in the austerity of his Meulan landscapes (*The Viaduct*, 1913) and in the discipline of his still-lifes, where the subjects are reduced to geometrical shapes as far from the aridity of certain too-faithful disciples of Cézanne as from the deliberate complexity displayed at that time by Braque and Picasso. Although he was a humanist Cubist, his sensitivity did not exclude a taste for grandeur and a certain heroic quality which strangely foreshadowed coming times: *The Conquest of the Air* (1913), now in the New York Museum of Modern Art, *The Fourteenth of July* and *The Artillery* (1913), and *Seated Man*, shown at the Indépendants in 1914, count among the rare monumental works of a period more concerned with analysis than vast synthesis. La Fresnaye had a natural instinct for balancing shapes. He did not reject the necessary disciplines, but did not let himself be imprisoned by them, and for this reason his compositions, dominated by large rectangular planes, are never devoid of life or movement. M. Jean Cassou, who has devoted some remarkably

lucid pages to La Fresnaye, does not fail to remark that Cubism satisfied his taste for grandeur and his horror of eloquence: extreme sobriety, rigorous vigilance and scrupulous purity were inflexible conditions for him, and since he was himself an artist of the most refined sort, this operation of decanting nature to which he devoted himself was effected without clash or violence. The titles of the paintings and drawings he did after the war, while attempting a hopeless cure at Grasse, tell enough about his physical and mental state: *The Suffering Man* (March 1922), *The Vanquished* and *Sick Young Man* (1924). Speaking in 1920 of the portrait of his friend Gampert, he wrote: "My whole time lately has been engrossed with a rather unfortunate undertaking: the portrait of Gampert in an old style, I mean recognisable and, as far as possible, like him. I worked very hard: drawings, oil sketches on canvas—it was all no good. Finally I came down to a sort of miniature and spent unlimited time on it. The result is quite interesting, but, all the same, does not justify all the trouble I have taken." From this period we have mainly drawings, water-colours and gouaches which he painted even when his advancing illness kept him in bed. Can they be considered a testament? La Fresnaye achieved mastery in 1911; from 1914 the war interrupted his work. When he resumed he had been so deeply affected that, after a brief return to the abstract in 1918, he embarked on an entirely different course. Constructional concern certainly continued to dominate during these attempts of his last period, but the appearance of things wooed him irresistibly, as though he were trying to hold on to the world he was about to leave. How his work would have developed had the war not intervened, no one can say. It is permissible to think, however, that the death of this strong, independent personality impaired the development of French painting as terribly as that of Francis Grüber was to do a quarter of a century later. (G. Ch.)

Le Corbusier (1887-1965)

French painter and architect of Swiss origin, born in La Chaux-de-Fonds, died in Roquebrune-Cap-Martin. Real name, Charles-Edouard Jeanneret. Apart from being an architectural genius, universally recognised as the revolutionary inventor of new forms and possibilities in concrete, Le Corbusier played an equally considerable part in the realm of plastic arts. Before beginning to study architecture at the age of eighteen, he had taken a course at the Ecole des Beaux-Arts in La Chaux-de-Fonds and knew the art of engraving. He was very attracted by Cubism, but criticised it for debasing its principles; painting, for Le Corbusier, while remaining both the subject and the object of emotion, had to hold strictly to the essential lines and colours it borrowed from the surrounding world. These conceptions evolved into a theory by the name of Purism in the magazine *L'Esprit Nouveau*, founded by Le Corbusier, with Ozenfant, in 1920. Aware of the excessive geometric and artistic discipline of his pictorial experiments, Le Corbusier always claimed to be avoiding decorative effects. To this end, after 1929 he tried to introduce the human form into his painting, which, until then, had concentrated on still-life. But the very terms of his rules guided him ineluctably towards mural decoration, fresco and tapestry. It is none the less evident that the liveliest humanism remained the constantly sought aim of his work both as a painter and as an architect.

Lipchitz, Jacques (b. 1891)

Sculptor, born in Druskieniki, Lithuania.

Intended for an engineering career, but interested in the plastic arts, he went to Paris in 1909. He took courses at the Ecole des Beaux-Arts and the Académie Julian. His meeting with Picasso, then Juan Gris, encouraged him in the Cubist style he had chosen. But the static appearance of Cubism did not satisfy him. He felt the appeal of shapes which were at once more subtle, complex and symbolic, his religious and humanitarian preoccupations mingling with erotic impulses. In 1940 he sought refuge in the United States, and in 1946 settled in Hastings-on-Hudson, near New York. His works include a *Madonna* in Assy Church.

Maillol, Aristide (1861-1944)

French sculptor, born and died in Banyuls. His studies of painting and sculpture at the Paris Ecole des Beaux-Arts having left him very undecided about his vocation, he started as a painter and weaver, influenced by Gauguin and Denis. He did not devote himself to sculpture until 1901, when he was forty, and did not really establish his personality until he came back from a visit to Greece in 1906. His early works, however, already show his preoccupation with sensual masses set in a mould close to that of Ancient Greece. Serene and static, concerned only with beauty and healthy sensuality, he differs in this way from the tortured and dynamic style of Rodin, to whom he nevertheless owed a great deal. Nearly all his work is based on a single subject: the female body.

Moreau, Gustave (1826-1898)

French painter, born in Paris. While he trained Matisse, Rouault, Marquet and Jean Puy at the Ecole des Beaux-Arts, and his generous and fertile teaching freely enabled each one of them to seek out his own individuality, he was at the same time a solitary painter of decadent romanticism. He was the contemporary of Villiers de l'Isle-Adam and Huysmans, and his art, which revived ancient pantheons in a dream-world of trivial fantasy, was, nevertheless, strangely prophetic. The Surrealists were making no mistake when they wanted to annex these haunted canvases where legendary figures—Sphinx, chimera, Salome—show off their androgynous anatomy amongst affected bric-à-brac sometimes gleaming with disturbing radiance.

Pascin, Jules (Julius Pinkas, known as) (1885-1930)

Many painters of central European origin who were interested in Abstract art gravitated to Germany. France, however, attracted the most remarkable of them: Chagall, Soutine, Kisling and Pascin. Pascin was born in Vidin, Bulgaria, on 31 March 1885, but was in Munich, and barely fifteen, when his deft touch was noticed by Gustave Meyrink, writer of the novel *The Green Face*, who got him into *Simplicissmus*, the most famous of the satirical magazines in which several German painters made their débuts, just as *L'Assiette au Beurre* and *Le Rire* were helping artists like Villon and Van Dongen to make a living in France at the same period. Turning his back on his success as a caricaturist, Julius Pinkas, calling himself Pascin, went to try his luck in Paris. These early emigrations show his longing for new horizons, and are evidence of his deep dissatisfaction. Had he stayed in Germany, no doubt he would have become involved with Expressionism, to which he was drawn by temperament. In France he found a more balanced atmosphere which, without detriment to his versatile touch or rich imagination, allowed him to escape from the temptation

of caricature, to which his friend the great artist George Grosz yielded, letting himself become absorbed by concerns foreign to painting. Pascin, by contrast, quickly discovered that inexhaustible subject, the female body. We are certainly indebted to him for admirable portraits of Pierre Falké, Mac Orlan, Salmon, Marcel Sauvage and Jean Oberlé, some extraordinarily fantastic compositions and innumerable sketches which are far superior to fleeting notes, but he remains the painter of woman, nude or slyly half-clothed.

At a time when the reign of pure painting was beginning, when the canvas was a surface covered with colours assembled in a certain order, he reverted to French 18th-century tradition. While Boucher's or Fragonard's coquettes, however, are limited to pleasing the fancy of the great lords of the time, Pascin's small, plump women are rather disturbing and, were there no mitigating humour, his eroticism could easily be oppressive. Looking at Pascin's life from the outside, it is all too easy to dwell on the appearance his journeys have of running away and on his death as a tragic melodrama. For those who knew him, he is remembered as a gentle, smiling man and a faithful friend whose only weakness was in leaving his choice of relationships to chance; as though frightened of being alone for a moment, he welcomed everyone who knocked on his door in the Boulevard de Clichy; painters, models, dealers and all sorts of spongers gathered round him every Saturday in some restaurant or other, and these companions were never presented with the bill.

His models were there, very young but well experienced. Pascin thought of them as "pensive cattle", and asked them only to stretch out on a divan or relax in an armchair with their slips raised enough to display their shapely bodies. He would take a large sheet of paper and draw on it in silver-point with single lines and no alterations. Then he would throw these sheets behind him, and they formed a large, untidy pile in a corner of the studio. Then he would take a canvas and rest it on his knees more often than on the easel. He dissolved a little pink and blue in benzene, and the flesh began to live. Or else he chose pastels, even more subtle, more apt for rendering all the flesh-tints of skin in half-light.

I am describing the years just before his death, when he appeared as a nonchalant smiling sleep-walker, always available for parties and orgies. Nevertheless, these were the years when he accumulated canvases which seemed to swell miraculously in number. He was rarely seen to work, but when he died at the age of forty-five he left an enormous body of work which may be seen mostly at the Paris Musée de l'Art Moderne and the Grenoble Museum, to which his wife, Hermine David, and his friend, Lucy Krogh, made important gifts. A great many experiments preceded that marvellous mastery he eventually attained. In 1907, in Berlin, he turned from caricature to complex compositions which already foreshadowed his future career. Then came France. Sure of himself though he could have been, he saw that he had still much to learn, and attended the Ranson and Grande Chaumière academies. In June 1914 he went to England with Hermine David. War broke out. In September he arrived in the United States. In 1916 and 1917 he spent a long time in Cuba doing many drawings and water-colours, then returned to the USA. He recorded his six years in the New World in innumerable sketches, not only of the Southern States, but also of New York, where he lived for a while in Brooklyn. Paul Morand tells us: "He visited Carolina, Louisiana and Havana, where the Creole languor exercised a definite influence on his work. Charleston, above all, engaged and intoxicated him, with its white, wooden, colonial-period houses buried in magnolias." Even more than the scene, however, it was the people who excited him. His water-

colours of that period give the impression that America was populated entirely with coloured people, all of whom were his friends. However much entranced by his wandering life, he missed Paris, and by 1920 he was back. Still he travelled again. In 1923 he went to Perpignan, in 1924 to Tunis, and in 1927-1928 he paid another visit to the United States. Despite these absences, he was firmly anchored in Montmartre, not in the old village dear to Utrillo, but in the night-club quarter with the crooks, with whom he was not above taking a glass of wine, leaning on the counter in some Pigalle bar.

Piraeus was the nearest he ever again travelled to the East of his youth, but he loved the Mediterranean—Marseilles, of course, and Italy, Spain, Algeria and Tunisia. This was his own Orient, where the women lurked in dream-stirring shadows. After a last journey to Spain came his protracted suicide on 2 June 1930. Pascin the nomad? That is easily said. I prefer Pascin the hard worker, whose evident facility should not disguise from us how much expertise there was behind the draughtsman, engraver and painter; his parody-like compositions on the subjects of *The Prodigal Son*, *Suzanna and the Elders*, *Socrates and his Disciples mocked by the Courtesans* and *Dives and Lazarus* are works which owe nothing to fashionable trends but communicate with moments of our own awareness. Pascin's drawings and most of his engravings are rapid series of strokes, sometimes done without lifting the hand, so excellent was he at integrating the shapes of his subject in one perfect flowing line. I remember the first time I visited him. It was late in the morning, but he had not been in long. Climbing out of bed, he threw on an old overcoat which was lying about somewhere. I went into that studio which was piled with drawings, pastels and engravings. While we started to chat, he seized a large sheet of paper and began a composition, without ceasing to talk in his low, calm, slightly monotonous voice.

To tell the truth, this master, who so admirably understood the most troubled aspects of his period, hardly belonged to it at all, and this is probably why he chose to leave it so soon. He loved the night like Rétif de La Bretonne, and his strange behaviour is too reminiscent of the heroes of Hoffmann or Chamisso for one not to be tempted to identify him with the most extraordinary of them. (G. Ch.)

Segonzac, André Dunoyer de (b. 1884)

In the years leading up to 1914, it was difficult to foresee the direction painting was going to take. Chance turned in favour of the Cubists, not only because, thirty years later, the Abstracts appeared to take over from them, but also because the group of painters faithful to reality were literally wiped out: Jean-Louis Boussingault, André Marc, Roger de La Fresnaye and Luc-Albert Moreau all died prematurely as a result of the war. Segonzac, in the catalogue to his 1960 exhibition at the Galerie Charpentier, wrote, "From 1910 to 1914, two distinct schools were exhibiting at the same time in the different rooms at the Indépendants. One consisted of Fernand Léger, Le Fauconnier, Gleizes and Metzinger; the other room, immediately opposite, included La Fresnaye, Moreau, Marchand, Boussingault and myself. Until the war in 1914, these two parallel and neighbouring schools were maintained without hostility, each defending a different aesthetic although linked by a distant kinship." This kinship was a rejection of the academic formulas then popular.

André Dunoyer de Segonzac belonged to a family line which could be traced on one side to the original gentlemen of Le Quercy, and on the other to great bourgeois such as the Persil (caricatured by Daumier), who was keeper of the Seals under Louis-Philippe. Born at Boussy-Saint-Antoine in

the Paris suburbs on 6 July 1884, Segonzac has always remained faithful to the Ile de France. He lives in Chaville, and it is the Morin valley which has inspired some of his most personal landscapes. Academic distinction at the Lycée Henri-IV did not foretell an artistic career, although he deliberately covered his exercise books with caricatures and attended the independent studio of the very official Luc-Olivier Merson. During his military service at La Flèche, he met Jean-Louis Boussingault just out of the Ecole des Arts Décoratifs, and this was a meeting as decisive as that of Vlaminck and Derain or Picasso and Braque. He soon formed a brotherly friendship with another young painter, Luc-Albert Moreau. They were both, without conviction, taking courses in Sudanese and Malagasy at the School of Oriental Languages, but they met mostly at Jean-Paul Laurens' studio, the Académie Julian and the Académie de la Palette where Desvallières and Charles Guérin had brought some of the spirit of Gustave Moreau's studio. After failing the entrance examination for the Ecole Nationale des Beaux-Arts, he rented a studio with Boussingault at 37 rue Saint-André-des-Arts. These young men thought that, beyond Impressionism (which all of that generation agreed to reject), they could link up with the tradition which went back to Gustave Courbet, and it was no mere chance that led Segonzac to acquire a masterpiece, *The Trout*, by the master from Ornans. They used a rather sombre style of great sobriety; their palette was based on earth colours and cold tones, and they determined to remain faithful to the objective observation of nature. Segonzac has never deviated from the way he embarked on then, from his 1906 study of a reclining man to his recent water-colours. No other body of work presents more unity; powerfully constructed, it refuses to make any sacrifice for effect, but its robustness is far from excluding poetry, as seen particularly in his

etchings for the *Georgics*.

At the Salon des Indépendants in 1909, he exhibited a *Venus de' Medici* which can still surprise us today by the boldness of its simplified shapes and the sonorous power of its texture: " I worked on this painting for three months," he tells us, " going back all over it and working with full impasto and in depth; it was really a reaction against the Impressionist school."

One man identified with the Indépendants was the painter Paul Signac; he was one of its founders, and was elected president in 1908. He welcomed all experiment, and feeling sympathy for these young painters, leased them the country-house at Saint-Tropez he had just left to go to a newly built villa which, as an old sea-dog, he had named La Hune (The Crow's Nest). Segonzac has remained at Saint-Tropez, and the Maures landscapes hold an important place in his work. Perhaps today he regrets having pointed the way to this unknown little port for so many friends, starting with Colette, whose *La Treille muscate* he illustrated in the very surroundings where it was written. Like René Clair, he is obliged to migrate away from the summer crowds, but in winter he hastens back to paint numerous water-colours where the gulf gleams through the pines.

Like Dufy and Van Dongen, Segonzac had a society period in his life, but it has left little trace in his work: a few drawings done at the circus or the boxing-ring, his series of sketches of dancers, his illustrations for Paul Iribe's *Le Témoin* and Jacques Rouché's *La Grande Revue*, and the slim book he produced on the Ballets Russes in 1910. The society life of those pre-war years was dominated by two men, Sergey Diaghilev, who revived the art of ballet, and Paul Poiret, who made his couture house in the Faubourg Saint-Honoré one of the high spots of French art. Poiret designed the costumes for a production of *Nebuchadnezzar* mounted by Rouché at the Théâtre des Arts, and the sets

were by Segonzac. It was Poiret again who paid 300 francs for his *Les Buveurs*, painted in the forest of Montmorency and exhibited at the 1910 Salon d'Automne. This is the earliest of the large compositions on show today in the room at the Musée National d'Art Moderne organised under the direction of the painter himself. But mixing in fashionable circles had no influence on his style which had never been more sober, more severe even, at least in his canvases, for at that time it could be said that it was the Parisian who drew, and the Quercy gentleman who painted. It was not until the war that these two aspects of his personality fused completely. After his mobilisation in the 353rd Infantry Regiment, he no longer drew Nijinsky, Fokine, Isadora Duncan and Ida Rubinstein, but soldiers in the trenches, soup fatigues at Bois-le-Prêtre, stretcher-bearers bringing in a wounded comrade. These are not merely documentary records, they have a lyrical lucidity; most of them are now assembled in the War Museum at Vincennes. From the trenches, Dunoyer de Segonzac passed to the camouflage section, with the rank of second-lieutenant. His *Notes from the Front*, published as an album, gave René Blum the idea of commissioning him to illustrate Roland Dorgelès' recently written *Wooden Crosses*. He hesitated. Until then his drawings, freely improvised on the subject, had been reproduced by photo-mechanical processes. Now he was being asked to engrave the etching-plates himself. He went and consulted his friend Laboureur, who taught him how to warm the sheet of copper and handle the acid; so a great engraver with very individual conceptions was born. In his preface to the exhibition of his engravings at the Bibliothèque Nationale he wrote: " I have always considered illustration to be a work parallel to that of the author, not a servile commentary on the text. The engraver must enter into the spirit of the book and, above all, create an atmosphere from it. In order to discover this, I have always lived the books I have illustrated." He is not only an admirable illustrator, but has also given us some evocative plates of landscapes, still-lifes, nudes, and the faces of Colette, Gide, Proust, Fargue and Henri Mondor. Vast as is his work as an engraver, it does not detract from that as a painter. Like the old Barbizon masters, with whom he has more than a little in common, he enjoys going in search of his subject. He sets out in the morning, his old car laden with canvases, palette and easel. When he has found a site he likes, he settles down and spends the happiest hours of his life in the depths of nature. For a long time he painted in the studio from sketches made on the spot. Then, as he became expert, he preferred water-colours of the subject; he treats these like oil paintings, not finishing them until after ten or twelve hours of uninterrupted work. Although Segonzac has always followed the same line, it is impossible not to notice a development in his technique and his spirit. Paradoxically, it was in his youth that he produced his dullest, most sombre works. Since, he has ceaselessly worked to gain his liberty, arriving at vividly coloured strokes which barely cover the canvas. He himself likes to point out his similarity to Cézanne, who at first used heavy impasto, while the fluidity of his later water-colours heralded the Tachists' experiments. His painting is solid in the resonant power of its texture, ambitious in the breadth of its subjects. He was twenty-five when he painted his *Drinkers*, and over the years he has embarked on large compositions which most of his contemporaries dare not attempt. His *Bathers* was a post-first world war event, with its robust and simplified shapes, and the boldly foreshortened female nude dominated by the standing man who has just come out of the water. Later, in 1936, he abandoned his gloomy colour-range when working on a similar composition, in the background of which is a *Mediterranean Beach* with its

landscape of sea and mountain and the crowd of bathers. Thus, in full possession of his powers, he has tended to become more abandoned, rejecting the perhaps over-deliberate element in his youthful works. Segonzac is one of those artists who, far from suffering loss of ability with age, acquire, at the end of their lives, total mastery. (G. Ch.)

Stein, Gertrude (1874-1946)

American writer, born in Pittsburgh, Pennsylvania. A pupil of William James, she came to Europe and settled in Paris around 1900. Her private hotel at 27 rue de Fleurus rapidly became a centre of attraction and meeting-place for French and Anglo-Saxon writers such as Sherwood Anderson and Ernest Hemingway, over whom she exercised a certain influence. She was a friend of Picasso, Braque, Gris, Matisse, Apollinaire and Marie Laurencin, and passionately defended Cubism, particularly commenting many times on the work of Juan Gris. Her *Autobiography of Alice B. Toklas*, published in 1933, recounts her memories of the painters she met—a trenchant and controversial evocation of the Cubist revolution.

Vlaminck, Maurice de (1876-1958)

Although genius can never be reduced to logical explanation, there is nothing against searching in a man's life for the elements contributing to his personality as an artist. The ancestors of Maurice de Vlaminck—Maurice le Flamand—were Dutch mariners. His paternal grandfather, a master tailor by trade, had taught his craft to his son before leaving it to open a café in Lambrechies, near Lille. Vlaminck's father, then, was a tailor until being attracted to music. He taught piano in Paris, and there came to know a young pianist, a graduate from the Conservatoire, and their son Maurice was born on 4 April 1876, in the district of Les Halles, at 3 rue Pierre-Lescot. All his life he was torn between the domination of his father, from whom he inherited a powerful temperament and a love of liberty bordering on anarchy, and the puritan influence of his mother, a strictly orthodox Protestant. The severity of the judgments he passed on the world around him, his literary tastes, his rages against the decadence of our civilisation can only be explained by knowing that in his childhood he regularly frequented the Huguenot church of Saint-Germain-en-Laye. He was seven when his parents went to live in Le Vésinet, and he passed his whole childhood in that suburb of Paris. Already, however, he was establishing his independence, and reacted against the family background, partly by teaching himself to play the violin instead of pursuing regular studies, partly by becoming a cycling enthusiast. It was by giving violin lessons, playing in gipsy orchestras and winning bicycle races that he supported his family when he married and rapidly produced two daughters. "The four of us together," he said, "were only forty years old."

At his grandmother's he met a member of the Society of French Artists, M. Robichon, who talked painting to him, and his best biographer, Florent Fels,[1] pointed out a harness-maker in Le Vésinet, who drew strange portraits in the crude colours of his trade, and much impressed the young Vlaminck. So he tried painting, but he attached so little importance to this diversion that he always painted over the same canvas, and when he had finished a landscape he would rub it in the grass before going home. Still, he deliberately diverted his route to go along the rue Laffitte or the rue Le Peletier, past the windows of dealers

[1] Art critic and historian (b. 1891); founder of *L'action* and *L'Art vivant*.

showing Impressionists. It was there, in March 1901, that he received a decisive shock: at the Galerie Bernheim Jeune, he discovered Van Gogh. There is no doubt that in the Dutchman's energy he discovered the answer to the questions he had been asking himself when contemplating his own work. "On that day," he has said, "I loved Van Gogh more than my father." Another important event was his meeting with Derain. While Vlaminck led a fairly disorganised life, doing anything and everything to support his family, André Derain was the son of well-to-do tradesmen from Chatou, although the bourgeois life hardly satisfied him. He also was seeking some diversion in painting, and he quickly welcomed the influence of this slightly older man to whom he confided his feeling for this art. In his book, *Post-Mortem Portraits*, Vlaminck wrote: "Without this meeting the idea would never have occurred to me to make painting my profession and live by it. It is equally certain that Derain owes to the same circumstances that he did not pursue the studies that would have led him to Centrale and made an engineer of him." The lives of both of them settled down in the 1900s. They together rented a studio on the Ile de Chatou where they painted all day long, the employment Vlaminck found as a second violin at the Théâtre du Château-d'Eau assuring his material wellbeing. Soon he became the painter of the melancholy suburbs, as Utrillo was the painter of old Montmartre. A little later, Ambroise Vollard put him and Derain under contract and sent them to London, but he was unable to accept this displacement; he wandered idly about until dusk, and Derain said to him, "Before you get down to painting, you're waiting for it to look like Chatou."

When Derain went off to do his military service, the two friends exchanged letters which Vlaminck published in 1956. Left alone, he continued to paint with complete spontaneity and even, apparently, with a certain spirit of fun, happily signing a landscape with the name of a very official painter sounding closely like his own: Flameng. In 1905, these years of apprenticeship came to an end. Derain was back, and side by side they exhibited at the 21st Salon d'Automne, the one the critic Vauxcelles dubbed the "*cage aux fauves*" (wild beasts' cage). Certainly Vlaminck was not the first painter of the Paris school to use pure colours "just as they came out of the tube". Van Gogh had done it before him, so had the Neo-Impressionists, particularly Signac, who stubbornly rejected any mixing of tones. Matisse himself concentrated on parallel experiments. But Vlaminck's influence was none the less decisive in all fields. Was it not he who revealed to Picasso those Negro masks which inspired his *Demoiselles d'Avignon*? Was it not he who induced the Montmartre painters to adopt the clothing of boxers and cyclists: caps, velvet trousers and roll-necked sweaters? Like him, Derain and also Braque and Van Dongen were of Herculean stature, and when they went to visit an exhibition together, this group of stalwarts from the Butte was quite impressive. Vlaminck was the greatest of all the Fauves, the most individual, the most passionate, the most determined to overthrow all traditions. His extraordinarily daring landscapes, still-lifes and violently coloured figures are arresting for their deliberate total simplification. The explosion was brief: *Apollinaire by the Seine*, *The Village* and *The Dancer at the "Rat-Mort"*, dating from 1906, are Vlaminck's last Fauve canvases.

Just as the retrospective Cézanne exhibition, following the death of the Impressionist master from Aix, influenced all the painters of that generation, and his *Puteaux Landscape* and *Still-life with Pitchers* could have been signed by Braque or Picasso, so the *Large Nude on a Divan* was a Matisse before Matisse. These years

of fermentation reveal a certain confusion among the young artists who had decided to bring all the pictorial traditions into question. Vlaminck, who was the first to devote himself utterly to these experiments, was also the first to find his ultimate way. The year 1908 was critical in his development. He moved away from Cézanne and the simplifications which would have led him to Cubism; the landscape *Tugs and Sailers* shows him resolutely taking the path of expressive realism from which he never departed. The reproach that Vlaminck has inevitably incurred is that he never renewed himself. At the age of thirty he was at the height of his powers. Certainly he did not always exploit his prodigious gifts as extensively as could be wished. Landscape and still-life were the two subjects he treated almost exclusively. The *Portrait of M. Itasse*, known as *Dear Friend*, painted in 1924, was only an ironic diversion. The man himself, however, is not absent from his work: it is he who has built these houses and these roads and planted these trees; he reveals his presence in the smoke rising from the chimney, the food collected in the kitchen: the allusion is more eloquent than the real presence.

As soon as he had broken away from Paris, pointedly describing it as a modern Babylon, Vlaminck refused to paint anything else but the images he brought back from his cross-country drives: heavy snow, the road disappearing under the bonnet of the car, petrol stations set up at crossroads like red memorials, gaunt trees, skies and seas swept by the wind of romanticism. These momentarily glimpsed sights were transformed in the studio into brooding canvases as violent in their blacks and dark greens as were formerly his Fauve canvases splashed with blue, red and yellow. His still-lifes, on the other hand, were not painted from memory, but only after he had arranged on the table the side of beef, the bottles and the stone pitcher. Here this great lyricist deliberately bridled himself;

he was content to observe, and asked the most humble objects, fruits and wild flowers to speak for him. The mastery recognisable in his most finished works he attained during the first world war which, although he did not leave Paris, was for him too the most moving event of his life. It led him to desert the capital, break with Derain and adopt a stubbornly pessimistic view of the world and life. He vacated his Montparnasse studio and settled in Valmondois, the country of Corot and Daumier, not far from Auvers, where Van Gogh committed suicide. But he was still too near the town, which he visited less and less often, and in 1925 he moved to the borders of La Beauce and Le Perche. There he discovered an old country house overlooking the gently rolling landscape. The immense horizon reminded him of his beloved Northern plains from where his family came. In the distance, as in Flanders, was a glorious belfry: from the bay-window of his studio, he enjoyed a wide view of the plain and could see the steeple of Verneuil-sur-Avre on the horizon. A sort of two-storey tower justified the name of La Tourillère. It was there that he died on 11 October 1958. (G. Ch.)

Weber, Max (1881-1961)

American painter, born in Bialystok, Russia, died in the United States. He was deeply influenced by his discovery of Cézanne and the Fauves when he lived in Paris between 1905 and 1908. When he returned to the United States he became the propagandist of the European *avant-garde*, notably organising the first Douanier Rousseau exhibition at the 291 Gallery in New York in 1910. His own work, influenced in turn by Expressionism, Cubism and Futurism, reveals a restless, anguished artist striving for an impossible synthesis.